DRAWING AND CARTOONING 1,001 FACES

DRAWING AND CARTOONING 1,001 FACES

Dick Gautier

A Perigee Book

To the lady on page 125

Perigee Books
are published by
The Putnam Publishing Group
200 Madison Avenue
New York, NY 10016

Library of Congress Cataloging-in-Publication Data

Gautier, Dick.
 Drawing and cartooning 1,001 faces / by Dick Gautier.
 p. cm.
 ''A Perigee book.''
 ISBN 0-399-51767-7
 1. Face in art. 2. Drawing—Technique. 3. Cartooning—Technique.
 I. Title. II. Title: Drawing and cartooning one thousand one faces.
 NC770.G38 1992
 743'.42—dc20 92-24951 CIP

Cover design by Bob Silverman

Printed in the United States of America
 6 7 8 9 10

This book is printed on acid-free paper.
 ∞

Contents

INTRODUCTION

Sir Thomas Browne wrote that "it is the common wonder of all men, how among so many millions of faces, there should be none alike." So it's no wonder that we have a fascination for the face, that Helen's face "launched a thousand ships," and that we watch talking heads on television every night of the week. The face is certainly the most mobile, expressive, and complicated part of the human body, and consequently the most difficult to draw. It's the focus of all human communication and interaction; our every mood, whim, desire, our very lives are etched there to be read in the slightest frown, smirk, or gentle tilt of the head.

First of all, let me say that I'm not going to attempt to teach you how to draw; rather, I'm going to try to teach you to teach yourself how to draw. I've always felt that teaching is like being a guide; you can show someone the quickest way through the forest, but you can't carry them, nor can you walk for them. The best I can do is provide a series of logical shortcuts, and maybe a few warnings regarding potential pitfalls. There's no substitute for those painstaking hours spent at the drawing board sketching and resketching and sketching again until you finally get it right.

If you were to compare the drawings done in the average person's youth with that person's attempts as an adult, you would find little growth. The same stick figures would fill the paper, and perhaps a silly little cartoon face or two. They didn't have the interest in art, nor did they take the time to start really "seeing" the world around them and trying to capture it graphically.

Let's stop to define our terms for the moment, without launching into one of those ultimately moot, semi-profound discussions regarding the pros and cons of various forms of art. Let us just say that art is a form of visual communication tinted by the individual artist's view of the world. That's the critical nub of the issue, that unique slant and style that each good artist brings to his or her work. My feeling is that artists are not only astute observers of the world with all its beauty and flaws, but documentarians who file away that frozen moment for rebirth in another form at another time; they are perspicacious note takers who see more clearly and keenly than the average person. In a classic *Rashomon* situation, where several witnesses disagree as to the details of a particular event or the color, shape, and size of the perpetrator of a crime, the artist would come closest to the truth in the descriptive process. Artists are creative sponges that absorb material and then dispense it at a later time filtered through their own experience and perceptions.

That's what we're going to try to learn first, to assimilate information about the face and head as it applies to portraiture, caricature, and cartooning; store it away for later use on an almost subliminal level as we pursue the art of drawing. Needless to say, we take part in a great deal of subliminal activity every waking moment; we make harsh judgments on that level daily. What is it that helps us to decide whether a person is ugly, attractive, beautiful, homely, handsome, plain, or cute? We are subconsciously comparing these faces with a paradigm in our minds of the perfect face; otherwise we'd have no standard by which to judge. Granted, this is a learned process, a dubious set of values thrust upon us by society, but nevertheless it is there, shaping our opinions about the multitudinous faces that we encounter every day.

First we're going to spend some time dealing with the basic dimensions of the human head. But I promise not to dwell on the names of the muscles and all of that strict anatomical information, as I don't really believe in its relevance to the art of drawing. The dimensions are a standard that we use to measure our progress as we go about the business of learning how to approach portraiture, caricature, and cartoons. We should learn to ''feel'' those muscles, to appreciate their functions, and be able to picture them and their movement under the skin, for it's only through a complete understanding of the anatomical structure of the face that we can pursue the art of drawing fully armed. We'll also investigate some of the techniques involved in creating your own faces, straight or cartoon. We'll focus on various features and learn how to integrate them correctly and proportionately into the face. We'll deal with shading, light sources, angles, facial planes. We'll go into the aging process, how children's faces differ from those of adults, and any other aspect of the human face that I can possibly include.

I have liberally peppered (read: littered) this book with many of my own sketches drawn from (he added immodestly) my rather fertile imagination and other faces that I've stolen from a variety of venues, such as restaurants, airports, parks, doctor's offices . . . wherever I found human beings with interesting faces. I highly recommend stealing features and heads and faces from everywhere. Look around you—there are many more than 1,001 faces from which to draw inspiration.

My hope is that when you're through with this book, you'll be well on your way to capturing a likeness in a portrait, capturing the humorous essence of someone in a caricature, or dashing off a silly cartoon at will. But remember that all of these abilities, if, in fact, they can be separated, stem from the same understanding of the human head and its structure, dimensions, and musculature. So let's roll up the sleeves of our artist's smocks (does anyone really wear those silly-looking things anymore?) and go to work.

BASICS

Before we begin with the basics, let's test your powers of observation, find out just how well your artistic eyes really see. Look at this drawing carefully and then try to pinpoint exactly what's wrong with it. Judge it on the basis of a realistic drawing, not a caricature. Can you root out the problems? Does it appear slightly grotesque? If the answer is yes, be specific. Why? What's wrong with the dimensions? Summon all of your intuitive and perceptive powers and see if you can figure it out.

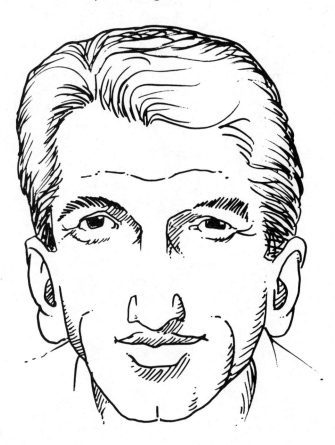

It was probably easier than you thought, right? And why? Because of that internal paradigm I mentioned earlier, helping us gauge when something's wrong. The next step is to take that feeling and transform it into constructive suggestions. It isn't always easy at the beginning to put our finger directly on the problem, but on some level we know that something's simply not right. If you can learn to critically take apart that aspect of the drawing that seems proportionately wrong and reconstruct it in your mind, and subsequently on paper, you'll be well on your way to understanding the true proportions of the human head. Ultimately, you'll be able to use that same critical standard to redo and develop your own drawings.

Okay, now look at the picture again. What's wrong? Are the eyes too wide-set? The ears too low? The mouth too close to the nose? Let's make a few minor alterations.

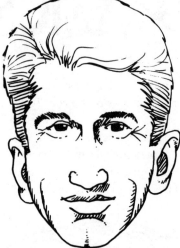

Did you spot any of these discrepancies in the picture without a hint from me? If not, you really didn't look carefully, you didn't use your interior hypercritical vision. We'll learn to bring these flaws to the forefront of your mind so that you can crystallize and then repair them.

The business of drawing is a "hands on" technique: a man can make a suit and never wear it, yet still he's a tailor; a man can write a song and never sing it, yet we call him a songwriter; but an artist is only an artist if he can draw. Drawing actually has very few rules; the things that one must memorize and understand are relatively few. The thing is to assimilate them so that they invisibly guide your every stroke at the drawing board. Now let's tackle these basic guidelines that help to shape our progress as draftsmen.

To build a human head from scratch, we have to start with the shape—the container, if you will—for the various facial features that we're going to place there. So we'll start with the oval, or egg shape. Sometimes this basic shape needs to be made a little squarer, narrower, longer, fatter, or rounder, but still the oval is at the base of it.

This is the shape that I most encourage you to practice drawing. It takes some doing to develop the facility to draw a freehand oval easily—you'll get it eventually, although you'll have to draw literally dozens of eggs to accomplish this—but it's a necessary skill if you're to draw the human head.

Before you proceed, however, there is another way to accomplish the same end, which is to use a combination of two circles, one slightly larger than the other . . . like this.

This will give you a workable outline of the head until you develop that freehand skill of drawing an oval.

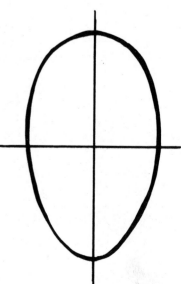

Now, if we divide that egg in half vertically and horizontally, we create four equal parts to the face.

The upper area of the head is known as the cranial mass, and the lower the facial mass. The two areas are equal to one another not only in dimension, but also in importance. Often students make the mistake of concentrating too little on the cranial area because, since it doesn't contain features, it seems rather dull by comparison. Yet it is a vital and important aspect not only in achieving correct proportions, but also in capturing a resemblance. On occasion this area can almost dominate the head, or sometimes it can recede, becoming secondary, but even that is an important difference that has to be calculated.

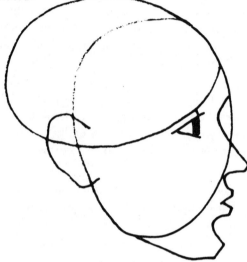

What appears to be a bizarre tattoo on this man's face is, in fact, the standard dimensions of our features. After drawing in the center horizontal and vertical lines, and cutting the head into quarters, divide the lower half of the face (the section below the eyes) into fifths. Then draw a line from the inside corner of the eye and move your pencil straight down to each edge of the width of the nose. Now move downward from the center of the eye and you'll find yourself at the outer edges of the ''mouth barrel.''

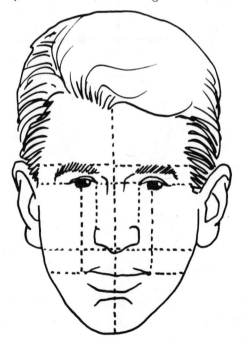

These rules and dimensions should become second nature. You have to know and understand the norm so thoroughly that you can safely vary from it with the subtle dimensional nuances required to do portraiture, the broader distortions required for caricature, and even the wild, bizarre abandon necessary for cartooning. Distortion in art is akin to that used by the jazz improvisationist who is able to hear the harmonic structure of a particular song playing in his head while he roams all over the scale finding the correct—albeit unusual—contrapuntal notes that fit harmoniously with his inner song. So this is not a chapter to be sloughed off or ignored; you have to have that correct dimensional paradigm so clearly embedded in your mind that you can refer to it easily at any given time. Now let's begin placing the features in their correct positions. Sketch the pupils in just above the top horizontal line. Now divide the area below the eyes in half; that will indicate the base of the nose. The nose should end at the approximate halfway point between the eyes and the chin, and the mouth another increment below that.

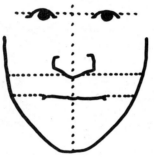

The inside corners of the eyes line up perfectly with the outside edges of the nostril wings.

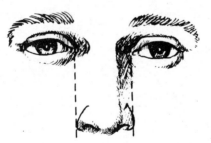

If you draw a vertical line from the center of the eye, it lines up with the corner of the mouth and the side of the chin.

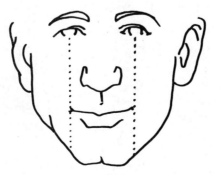

To place the ears in their correct position, let's return to that side view.

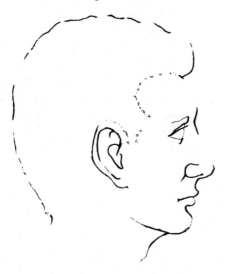

The ears are almost (I stress almost) in the middle of the head; if you were to draw a center line and then place the ears just behind that mark, that would be correct. This is a critical measurement because, as in the illustration below, the misplacement of the ears can ruin an otherwise well-proportioned drawing and make it appear amateurish.

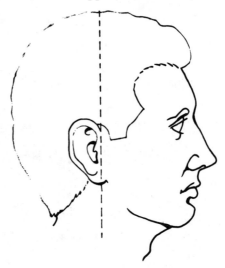

The tops of the ears are even with the eyebrows, and the bottoms of the ears end at the base of the nose. They rarely vary much from that placement, give or take a micromillimeter or two, so that can remain a fairly consistent guide for you.

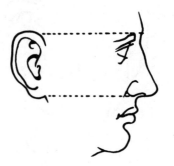

The angle of the ears is also an important consideration. The ears do not, as commonly believed, cling vertically to the head, but rather at a slight angle.

This is correct. This is not.

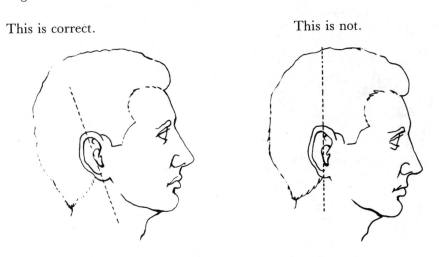

This illustration demonstrates an ear that is too far forward. This causes the remainder of the head to be out of balance; the rear of the head is sliced off, producing an extremely narrow (and goofy-looking) profile.

The equilateral triangle is very useful in placing the ear correctly. The three points of the triangle should touch the outside corner of the eye, the base of the chin, and the back of the ear. Using this device, you can always verify your ear placement.

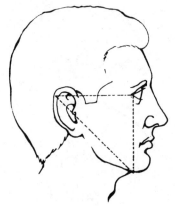

No, this isn't a refugee from a Wes Craven horror flick. It's merely a way of demonstrating that between two normal eyes the measurement should be one entire eye width.

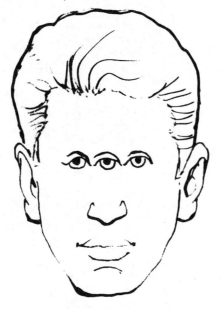

Our faces are actually five eyes wide.

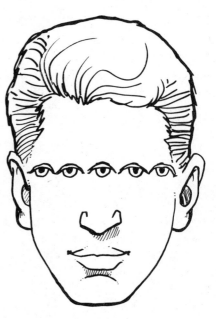

Eyebrows are measured at about a half an eye, although women will pluck, reshape, and pencil in different brows. So there is a lot of room for creativity here.

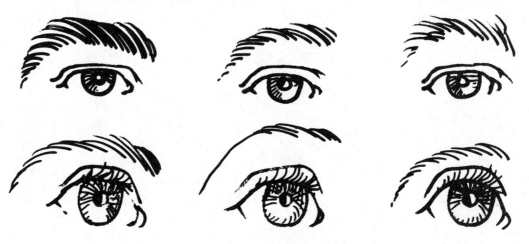

As far as correct placement of the mouth is concerned, there is another handy guide, again in the form of an equilateral triangle, that can help you to check this out. Position the triangle so that it intersects through the center of the pupils and the point ends at the bottom of the lower lip.

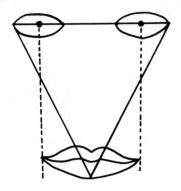

The upper lip is fuller than the lower lip, and protrudes slightly.

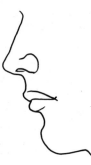

If you were to draw a straight line from the nose to the chin, the mouth would usually be recessed a bit.

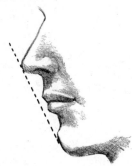

However, in some full-lipped people all points could touch the line.

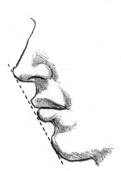

The male and female heads have distinct differences: The male brow is more prominent, the nose larger and straighter, the lips narrower, the jawline stronger and more pronounced, and the neck thicker. The female has fuller lips, a smaller (usually curved) nose, heavier eyelids, longer lashes, and a more delicate chin.

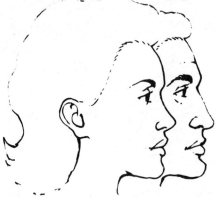

You also have to take into account the slope of the head; there are many degrees of slope to the face, but the primary ones are the steep, diagonal, and moderate slopes pictured here. These slopes also affect front and three-quarter views; it's not limited to profiles. In a steep slope the features are more on a vertical line, so consequently the nose and mouth do not protrude as much. In the diagonal slope the upper mouth portion juts out and the head recedes back, causing a radical difference in the features. The moderate slope lies somewhere in between these two extremes.

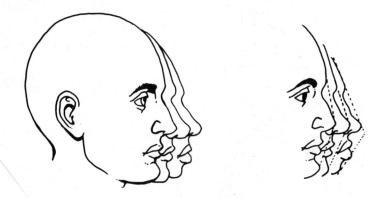

When you want a head to turn, it's helpful to picture the head encased in a cube, with the measurements intact. That way, when the face moves, everything moves.

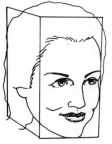

As the head turns, monitor all the measurements and dimensions; they should remain constant.

In a three-quarter view, start the center line a quarter into the head and carry it down in a curve as if you had drawn a line from the brow to the tip of the chin. Note that the corner of the opposite eye is hidden behind the bridge of the nose but the other dimensions stay the same.

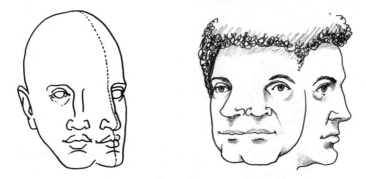

When you begin a drawing, it's also important to judge whether the face is below, above, or at eye level, for that will dictate a change in the features and the head.

These are at eye level.

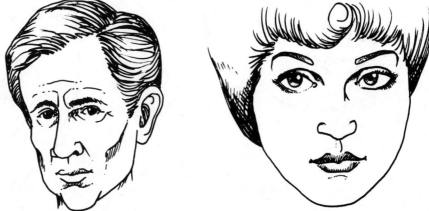

Here are a few heads looking upward (or possibly the artist was positioned slightly below the subject). You can see that more of the nostrils are exposed; the jawline changes radically; the upper lip takes on more importance, since the lower lip is foreshortened slightly; the eyes alter in appearance; the pupil is positioned differently; the upper lid forms an arc; the lower lid appears nearly straight; and the ear is lower.

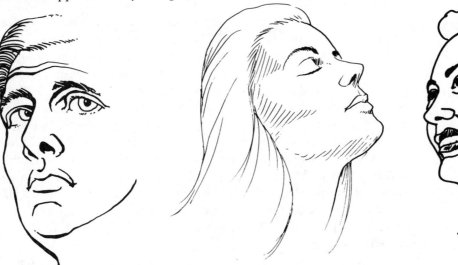

When we move above eye level, the exact opposite occurs: the parts of those features that dominated are now less important. The lower lip is accentuated, the brow dominates, and the lower eyelid curves. And now the ear is placed higher.

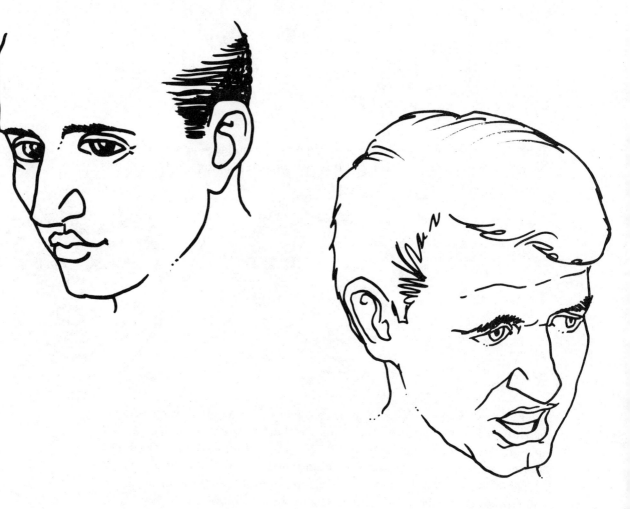

Okay, now it's your turn. Look at yourself in the mirror and apply these rules and dimensions to yourself. Review and re-review these shortcuts designed to aid you in checking your own progress and understanding. And the next time you're out in public, start becoming hyperobservant; look at people's faces and apply the principles you've learned here. Picture a grid on their faces and see how it works; draw invisible lines from the top of the ear to the eyebrow and the bottom to the base of the nose. Trace an invisible line from the center of the eye down to the edge of the mouth barrel. Or if you run across some interesting faces in magazines, do the same thing with a pen or pencil. After a while, you'll feel an inner key turn when all of this starts falling into place. That will be the turning point, and you'll know that you're on your way to understanding the basic facial concept. Then on to the next step, which is much more fun . . . actually getting in there and drawing.

FEATURES

Features each have their own distinctive pluses . . . and pitfalls. The eyes are often misrepresented as having a perfect almond shape, the ears are placed in too vertical a line, the nose is a bit difficult to draw at first so often it comes out looking more like an ambitious turnip, and the mouth has its own unique set of problems. Let's go through them one at a time, and I'll try to anticipate your questions and answer them for you.

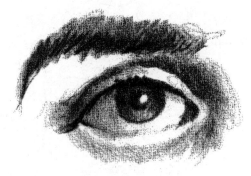

The eyes are the most expressive feature of the face, because of the intricate network of muscles that surrounds them. They are the focal point of any communication between human beings: we look in one another's eyes for signs of tenderness, hostility, empathy, or sorrow, so this is a critical feature to master.

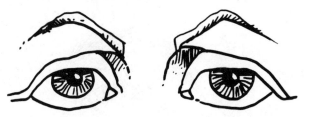

As I mentioned, eyes are often perceived by the beginner to be almond or football shaped and absolutely symmetrical. They are actually ellipsoids that curve downward toward the outside edge of the face.

The upper curve of the eye is more pronounced than the lower, and the lower lid is recessed into the head on a slope of forty-five degrees. This can best be observed from a profile view.

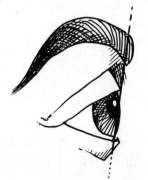

The apogee of the upper curve is closer to the inside corner of the eye, and tapers away from that point. The lower lid is less dramatically curved.

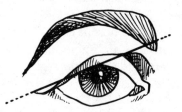

The pupil seems to hang from the upper lid, appearing not to make contact with the lower lid.

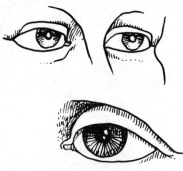

However, if too much white appears beneath the pupil, the eye takes on a rather sinister appearance, known as *sanpaku*.

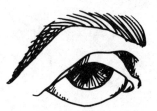

To draw an eye, start with that basic football shape and then allow the upper lid to taper down away from the center.

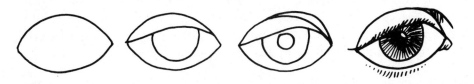

There are distinct differences between male and female eyes. The female's lids are generally thicker, and the eyelashes are fuller and longer and serve as a more dramatic frame for the eyes.

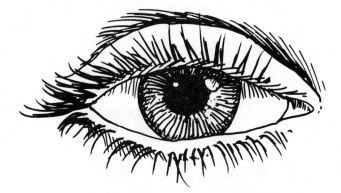

The male eye has fewer lashes and a leaner lid.

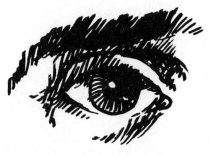

The brows wield great influence on the character of the eye; they act as a small frame for the eye, much as the hair does for the face. Here are a female and a male eye with different sets of eyebrows.

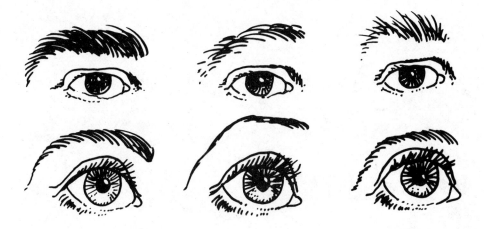

The nose doesn't move much, save an occasional crinkling up. However, since it is our most convex feature, and the most dominant feature on our face, its importance should never be underestimated. Its contribution is so strong that we can say the nose sets the tone for the face. Noses come in a plethora of shapes and sizes, and most of them have been given names over the years: the aquiline nose, the Roman nose, pug, Greek, etc.

The nose is basically a wedge-shaped triangle composed of the upper nasal mass (the bridge), the tip (or ball), the nostril wings, and the hook of the nose (the septum), which fastens to the pillars of the lips that flank the philtrum (yes, that funny little depression directly in the center of your upper lip does have its very own name).

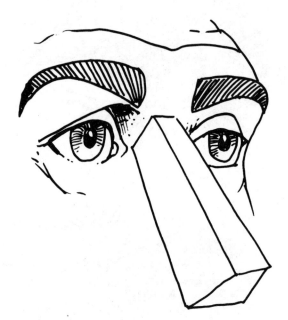

And these four components can give rise to an incredibly wide variety of shapes.

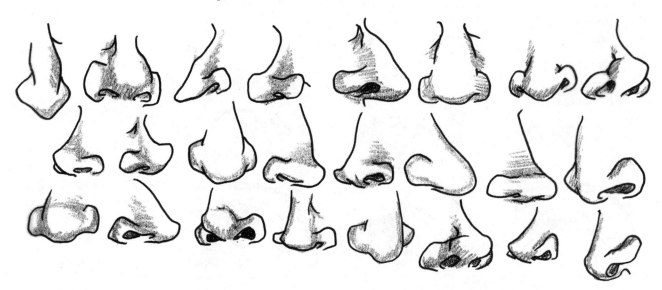

The width of the base of the nose measures (here's that handy measuring device again) exactly one eye width, the same as the distance between the eyes measured from the inside corner . . . hence this bizarre illustration.

The upper section of the nose generally is one half its length; the bottom half comprises the hook or septal cartilage. I don't think it's necessary to agonize over memorizing these anatomical terms, although you should understand the principles.

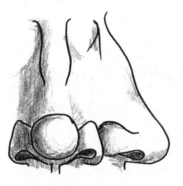

Here are the elementary differences between male and female noses: The male nose is larger and straighter, and the nostril wings are more pronounced; the female nose has a gentler inner curve and is generally more delicate.

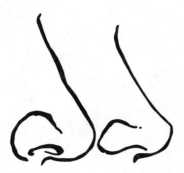

Mouths vary slightly in width, but it's the lips that make the real difference to the overall look of the face. Are they slim, nonexistent, or full? The upper lip is, as a general rule, fuller, especially with women.

Men's lips are generally balanced, the upper and lower more evenly matched.

These, of course, are broad generalizations; exceptions abound all around us.

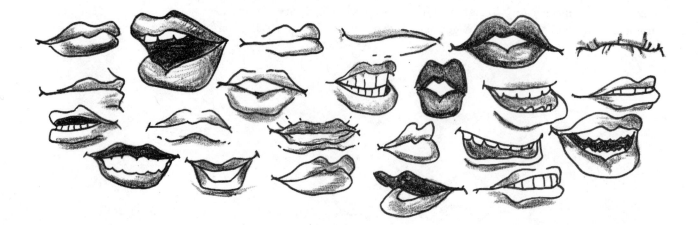

Ears don't do a heck of a lot except cling tenaciously to the sides of the head. They can be oversize, delicate and shell-like, or thrust out like the wings of a jet plane, all of which are bound to make a strong contribution to the subject's appearance. Ears follow a very definite pattern and don't vary much from that basic shape.

On occasion the lobes will be more pronounced or taper off to virtual non-existence on the cheek.

To arrive at the correct proportion for the ear, divide its length in thirds, then check to see that the widest part of the ear (at the highest part of the ear, the outer rim) is half the length.

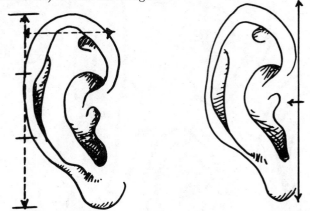

The top third of the ear ends where it attaches to the side of the head.

The second section is the largest opening, the bowl.

And the bottom section, the third part, is the lobe.

The tragus, that small, hard piece of flesh that covers the hole to the ear, is the midpoint of the ear.

To draw an ear, start with a top-heavy C or shell shape. Then sketch in the outer rim, as shown here.

Now add the large inner curve. Tie in the rim to this curve and add the indentation at the upper part of the ear, just below the outer rim.

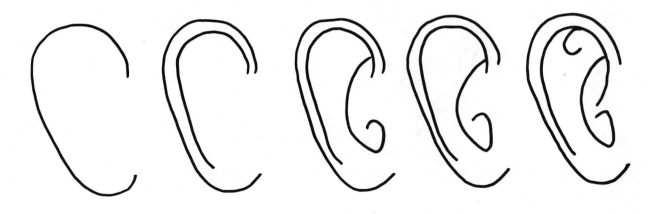

Generally speaking, ears are pretty uninteresting, but if you really look around you, you'll see more than a few variations on this limited theme.

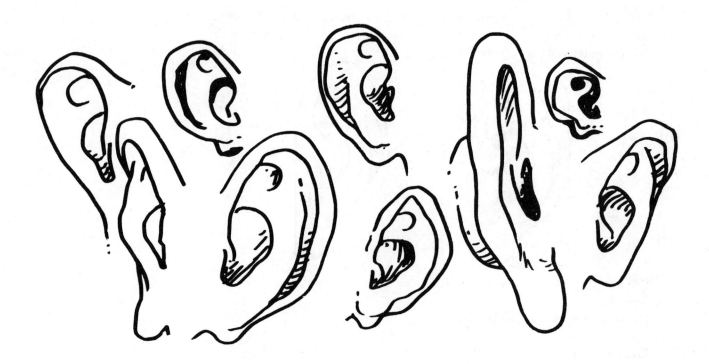

As I mentioned previously, the hair acts as a frame for the face and is capable of changing a person's look in myriad ways. Women, more so than men, can alter their appearance radically just by changing their hair. A woman can appear severe or soft or mysterious merely by the rearrangement of hair. A full curly mane suggests one thing, while straight, loose tresses say something else about the person. Let's take an average woman's face and not only alter the color of her hair but change her hairdo several times.

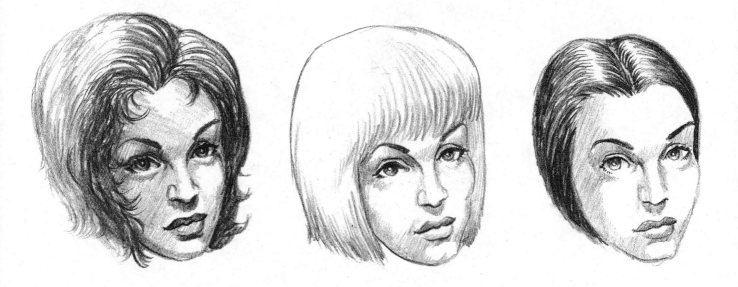

When you draw hair, it can either be a mere suggestion of the flowing contours or it can be a meticulous hair-by-hair rendering, depending on your choice of treatment.

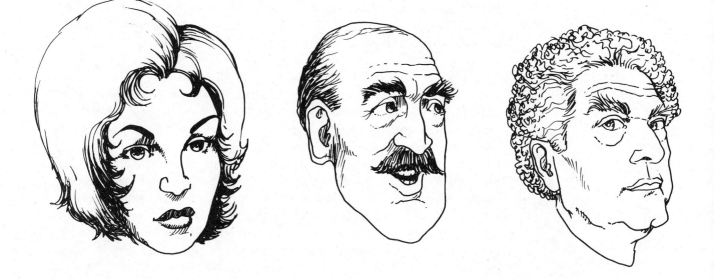

Chins are considered strong when they're prominent and weak when they recede. If a person has upward-slanting eyebrows, we regard him as evil-looking because of our conditioning to renderings of Satan with those same saturnine slanted eyebrows. The implication is that a person's character is shaped by his or her individual physiognomy. Nothing could be further from the truth, and this belief merely helps perpetuate those myths regarding appearance that we hold so dear.

You should be aware of the physiognomical clichés that exist, and try to avoid them. However, there will be times when you have to depend upon them and you'll find yourself, out of necessity, giving in to the cliché.

To create a new face for a painting—if, for instance, you don't have a model available or you have a clear, preconceived idea of what you want—you can build your own with a one-from-Column-A, one-from-Column-B approach. Try it; it's fun, interesting, and creative, it works very well, and it's as close as you'll ever get to playing God.

As you know from my earlier urging and cajoling, I firmly believe in time spent at the drawing board. With features, I recommend drawing them individually without introducing them into the face yet. It gives you a firmer grasp of their essentials if you're concentrating specifically on the features and not concerned about their integration into the whole. Find a flock of faces in your favorite magazine and draw only the noses or the eyes. Then put the magazine away and see if you can identify any of the faces merely by the shape of the nose or the look in the eyes. In other words, zero in on the features and become completely comfortable with them prior to attacking the entirety of the face. As you've learned, the face has its own set of dimensions and the various features have theirs, and there are more sets of dimensions to come based upon the inclusion of the features. So work specifically for a while; you'll know when you're ready to move into the larger picture.

PORTRAITURE

Historically, portraiture has, on occasion, been reduced to merely a demi-art; when the artist was commissioned to paint a portrait it was an unspoken mandate that the artist adhere to a rather flattering view of his employers—hence the hundreds of stiffly posed portraits of innocuous-looking people in ridiculously overstated clothing that line the walls of many museums. On the other hand, real, honest portraits painted with frankness and skill have weathered the centuries and are among our most revered paintings. To leap to the obvious, the Mona Lisa, *Whistler's Mother* (real title: *Arrangement in Black and Grey*), and van Gogh's self-portraits all fall into this category. In a great portrait something mysterious occurs: the artist, in capturing the surface resemblance, also makes us feel that somehow we're being given a brief glimpse into the subject's soul. The artist has managed, through sheer dint of superior ability, to convince us that we now know, or at least understand, the person whose likeness adorns the canvas.

I see portraiture as the art of revealing, the peeling away of the subject's social mask. It's the ultimate level to which you should aspire . . . but first let's address the business of how to capture that initial surface likeness. If you were to walk into a beginners' portraiture class and see a group of unsigned paintings of one particular model, most likely you would be able to pair up the paintings with the students. You would find a resemblance in each canvas to the student's face. Beginners rarely paint the model, although they try; they unwittingly paint the face with which they are most familiar—their own. Why? Because they are not really ''seeing'' the model's features clearly. That face is being screened through memory, ego, and the inability to recognize the correctness or incorrectness of spatial relationships.

In her classic book *Drawing on the Right Side of the Brain,* Betty Edwards has students draw a portrait upside down, and the improvement is remarkable compared with their prior efforts. Why? Simply because the eye is forced to discard all previous visual assumptions and really focus on the minute measurements of the spatial relationships required to capture that elusive likeness.

When first endeavoring to do a portrait . . . don't. Don't try for any resemblance. Draw the person you see before you, but don't try to capture a likeness. Also, don't start out with a drawing of a family member or friend. They'll put inordinate and premature pressure on you to have it resemble them, and for now you just want to make it look like a human being.

A good starting exercise for portraiture is to try to capture the face in a few strokes. Time yourself; stop drawing after thirty seconds and view the result. It might surprise and perhaps delight you, for working under the pressure of time doesn't allow you the luxury of getting constricted and nervous. I did this super-speedy sketch with one of my favorite techniques, using a felt-tip pen and smearing in the shading with the moistened tip of my finger.

This one took roughly a minute, using the side of a charcoal stick.

Or plunk yourself down in front of the TV set and furiously draw every face that appears for about five minutes. Then stop and assess your work. Where did you fail to capture the people, and where did you succeed? It's a very effective shorthand way to discover your strengths and weaknesses.

I always like to make several quick freehand sketches of a subject prior to settling down to the portrait. It helps me to focus on the areas that I feel are most important in this particular face, and my hand, without too much objective overintellectualizing, often seems to tell me that. I like doing loose, easy sketches, often without removing pen from paper, a series of uninhibited scribbles that capture the basic shadows, the form, the essence of the face.

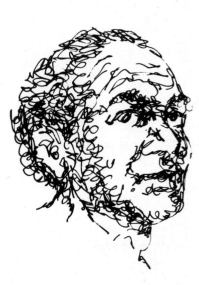
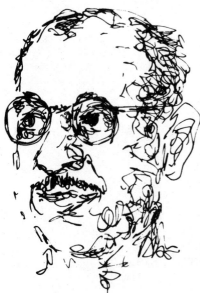
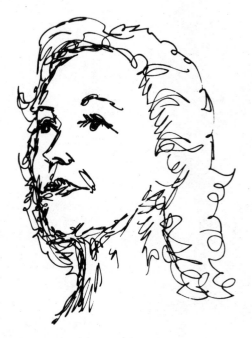
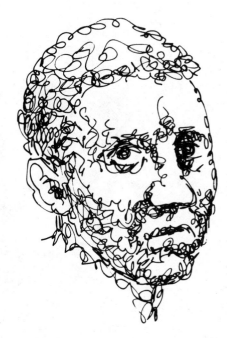

This done, I sit down and approach the work from a whole different angle. I want to make clear to you that this is the process that I have found works for me. It might not ultimately be the way that works for you, but for now give it a try. You can always make your own changes later on, when you reach a higher level of proficiency.

At the first phase of the portrait, I start with a rather conventional sketch, a drawing of the nearly perfect face complete with all the standard perfect dimensions. Since this bears no resemblance to my model, I then go about determining where the measurements go awry. Are the subject's eyes a little closer together? Is his nose longer than the norm? Is her hairline a bit low or closed in at the temples? Conceptually it reminds me of the old joke about the sculptor atop the large block of marble explaining how he's going to sculpt an elephant. He says, ''I simply chip away everything that doesn't look like elephant.'' In a sense, the same applies here. I leave alone the areas that don't require any work, concentrating only on what varies from

the norm, and I keep on doing that until a resemblance begins to emerge. Encouraged, I move on to the next level of effort, attempting to find an expression that reveals something other than the external of my subject. When I'm satisfied with this aspect of the work, I then determine what pose suits this particular person. Then clothing and background, until finally I have a complete concept with which to pursue the real portrait. All of this is just the preliminary work leading up to the main event—the actual portrait.

The difference between your face and mine or someone else's is only a matter of millimeters or maybe micromillimeters. The nuances of dimensional differentiation from face to face are often so infinitesimal that your assessment and execution of the subject's facial measurements have to be focused upon with great care and intensity. We're trying to make that comparison to our interior grid right out here on the canvas or sketch pad where we can really deal with it.

Let's take an abstract face, only a series of dimensions at this point, and slowly try to find the portrait hidden within. We'll subtly change it, infusing it with character. First of all, note whether the head is tilted, downcast, or upraised. Find the angle and do your preliminary sketch.

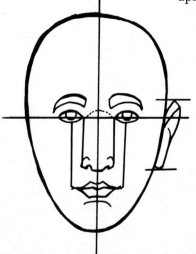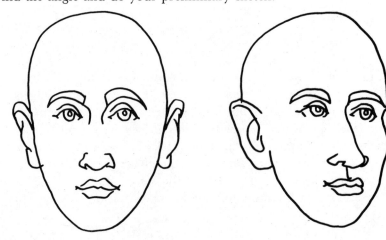

A common pitfall here is in the angling of the head. When the head is tilted, the features must angle also and remain constant. That is, don't allow your preconceived view of the usually upright human head to distort your perception and allow you to place the features incorrectly, as pictured here.

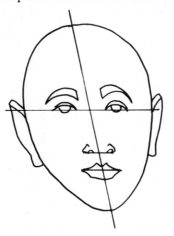

Features tilt when the head tilts, and dip when the head dips. I know that sounds oversimplistic and obvious, but failing to record such alterations of the features is one of the most common mistakes committed by the novice. We are so conditioned to viewing the features in an upright position that we don't automatically make the proper allowances when the head angles or leans.

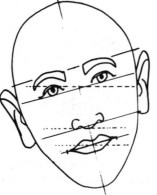

Practice drawing heads at a tilt with friends or family acting as models, or fall back on the good old standby magazines again, whichever is more convenient. Remember to skew all of the features accordingly.

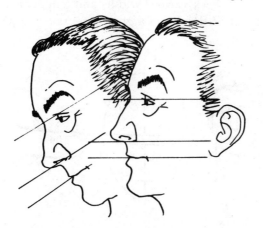

First we must determine whether we're dealing with a frontal view, three-quarter, or profile. Is the head above, below, or at eye level? This particular portrait will be at eye level and a three-quarter view. Make the necessary adjustments as discussed in Basics, then sketch in the grid of the face with the appropriate measurements.

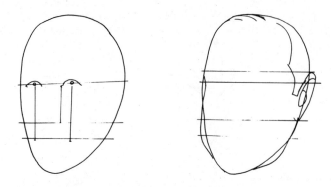

Don't make the mistake that I mentioned previously, that of giving short shrift to the cranial area. In fact, after you make that initial oval to begin your drawing, add a little to the top of the head and the sides for the thickness of hair. This will be invaluable when you step back for that objective look for correctness of dimension and (you hope) some initial resemblance.

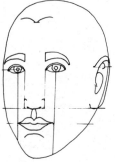

Although the hoary old cliché of the artist measuring a subject with an upraised thumb has become almost an object of ridicule in our culture, in actuality it has merit.

Most artists use a pencil for this eyeballing measurement technique by holding it horizontally in front of their face and moving their finger up and down the pencil to check various widths and lengths against the sketch before them. It is very helpful and a great time saver, especially in the initial stages of a portrait.

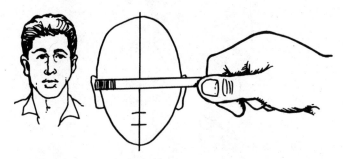

Using your pencil (your finger acts as the critical measuring spot), measure the distance between your model's eyebrow and hairline, the jaw, the width of the cheeks, and so on until you've covered every minute measurement of the face. Now look at the picture again. Do you see a resemblance, even before you've sketched in the features? You should. Just the rough dimensions of a face are enough to start a pretty fair likeness. Now concentrate on the features themselves. Notice that the nose is slightly longer than normal and the jawline and cheeks bulge a bit. Sketch in the hairline. As we deal with specific features, a person actually begins to emerge.

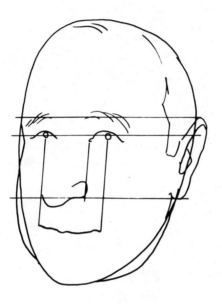

You have to learn to objectively assess each dimensional element and feature of the face. If one element is lacking, the entire likeness suffers. Each tiny component is as important as the next; cumulatively, they'll achieve that sought-after resemblance.

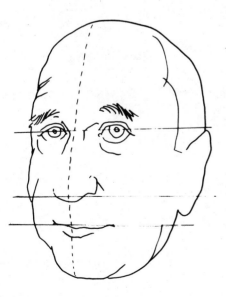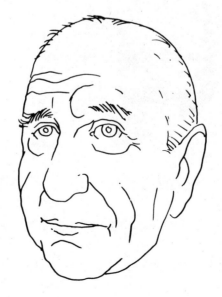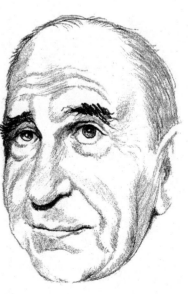

And don't be shy about asking friends or family to pose; they usually are flattered and most eager to cooperate. (As long as you tell them that this is *not* a portrait, they won't become hypercritical.) That being difficult, of course, there are always magazines, the library, and a variety of other sources. Personally, I'd rather work from photographs, even for a portrait of someone who I know will pose for me. My reasoning is that photos allow me the luxury of emotional distance. I don't want to get seduced by my subjects' charm at sittings. It just might influence my view of them.

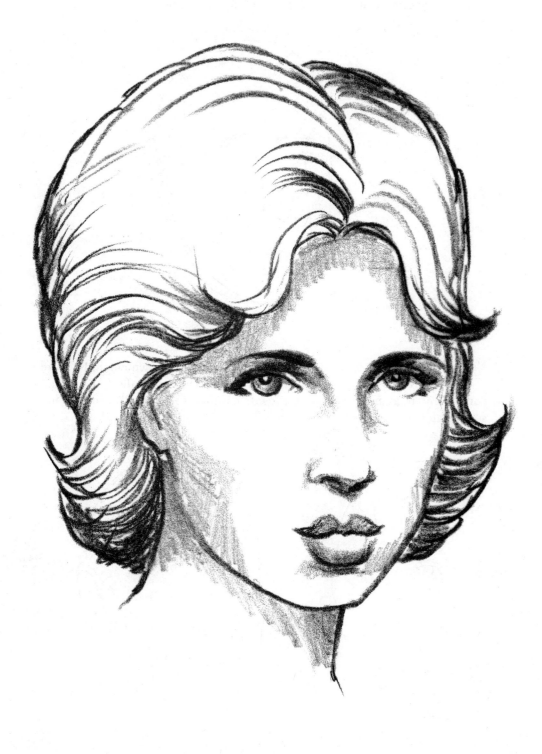

Sketch someone and try to nail down a likeness only with the shape of head and hairline. You'll be surprised how recognizable those things alone can be. Have you ever been walking down the street, spotted someone from behind at a great distance, and instantly known who it was? Of course, we've all done it. What we recognized was the masses (we weren't close enough to actually make out features) and the attitude, the rake of the head, the jaunty walk, the swing of the arms. You can do the same thing with a drawing. Use only a suggestion of the masses and you'll produce a surprisingly successful portrait. Then, and only then, begin to add features. As they merge with the overall picture, you'll be amazed at the incredible likeness before you. You can liken the rough, overall dimensions to a platform or a superstructure: if that's sound, the building will stand; without it everything else is off and ultimately in danger of collapse.

So round up your friends, relatives, schoolmates, whomever you can con into sitting for you, stock your studio or kitchen (or wherever you choose to work) with pictures gleaned from magazines or whatever, and start drawing, drawing, drawing. There's a multitude of faces out there waiting to be captured, and each one provides a new and exciting challenge.

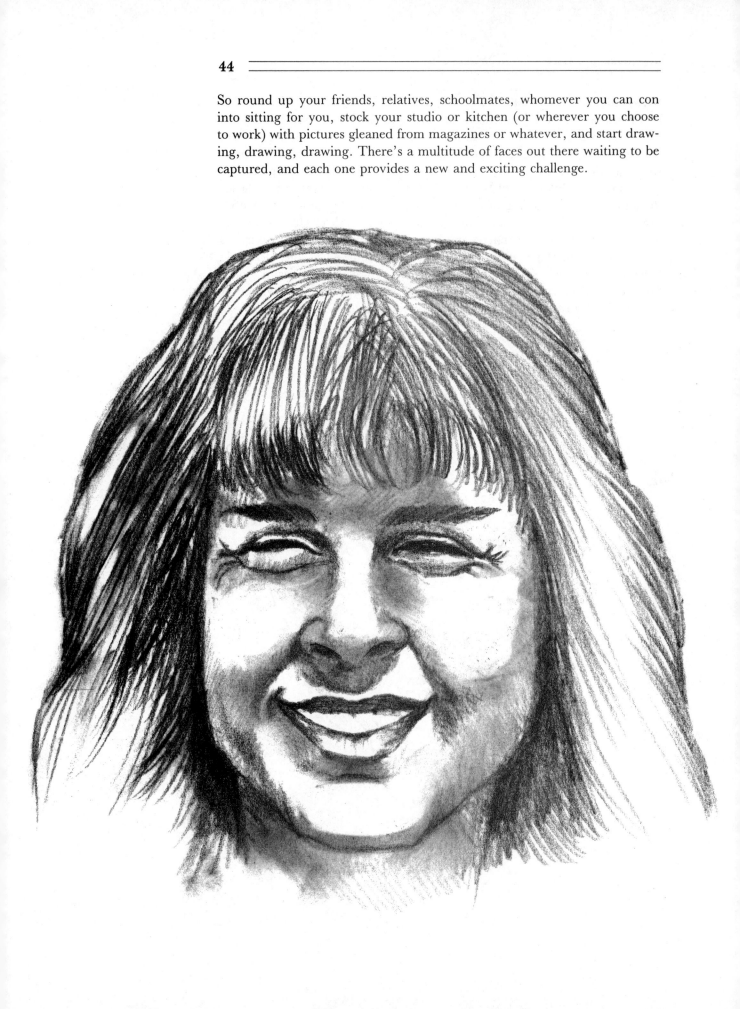

CARICATURE

I've always felt that caricature is nestled somewhere in between portraiture and cartoon; it's a humorous, sometimes cruel view of a specific person's likeness. Artistically it's uniform or controlled distortion, a lighthearted yet recognizable piece of portraiture. All that said, I guess you could call it a form of civilized ridicule.

Caricature is an old art, but its expert practitioners have dwindled noticeably over the years because of decreased demand for the product (much as with satire in America). Now we are exposed to caricature mostly through those safe, cute little cartoons done at fairs and sidewalk stands, but I don't consider those caricatures. To be a true caricaturist you have to go for the jugular at times, be a bit ruthless in your approach, try to reveal the inner essence of a subject through your drawing. Editorial cartooning is probably the last bastion of decent caricature in this country.

Caricature has also been called the art of exaggeration. However, to exaggerate doesn't mean merely to make larger. It means also to overstate or take beyond the bounds of the truth, so that would include extreme understatement. For instance, if my subject (read: victim) has an extremely diminutive nose, I'd scale that nose down to next to nothing . . . or make it disappear entirely. If the nose doesn't make a worthwhile contribution to the face, it'll be more effective in its absence.

Caricature, much like portraiture, is not dependent on just one or two features or aspects of the face, but rather on an accumulation of exaggerations and distortions that will ultimately produce the resemblance you're seeking, laced with that all-important humorous bent.

There is a step in between a portrait and a caricature that the French call a *portrait chargé,* or loaded portrait. It bridges the two in that it possesses all of the correct facial measurements save one or two features. If I were to draw a fairly realistic sketch and then exaggerate certain dimensions only slightly, that would qualify as a *portrait chargé.*

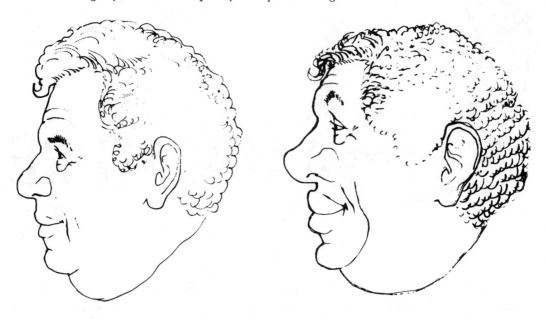

Here's another example of this technique. In this case I pounced on just one feature, the chin, and left everything else intact.

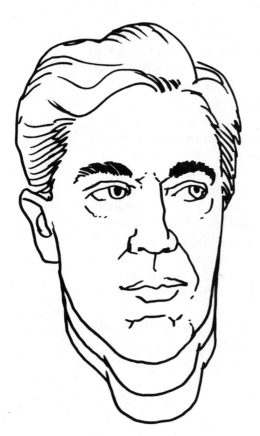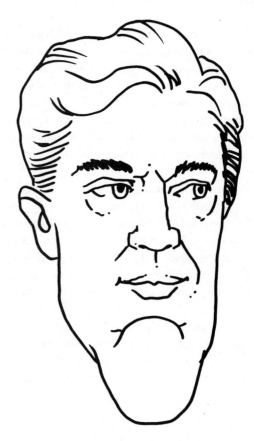

I was struck by this man's bald head and chin, so this drawing resulted. You can see that, other than those key areas, this remains a fairly accurate portrait.

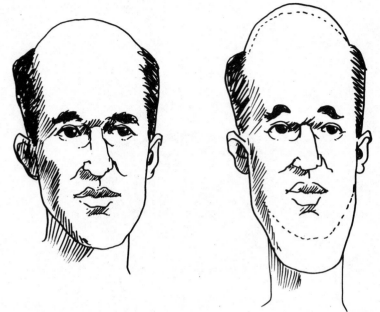

Let me show you an array of faces. I'll take them from portrait to caricature so we can analyze together exactly what it is that was extended, shortened, widened, narrowed, or generally distorted.

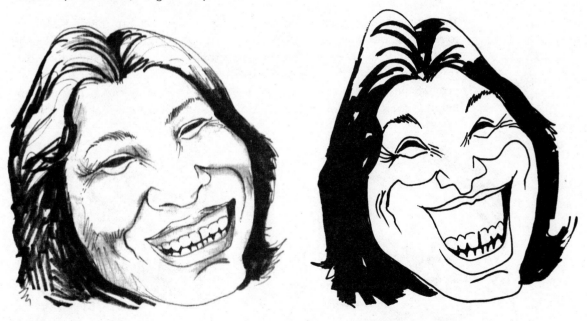

The subject's head appears pear-shaped, but primarily because of her small forehead. She has squinty eyes, a large mouth but exceptionally small teeth, and lots of gum. Her hair is also important, dark and flowing. Assessing her face, we'd say that her dominant features are her hair, mouth, and eyes; her nose and ears are subdominant. We'll assess each face in this section in that way, by dominant and subdominant aspects.

In approaching a caricature of Michael Jackson there's a problem, a certain unisexualism about his face that makes it difficult to do. There are his almond eyes and nearly nonexistent nose, but I found it necessary to rely upon other things in order to achieve a likeness: gimmicks like his unique hairstyle (which unfortunately changes so frequently that by the time this book goes to press it'll be outdated) and the hat.

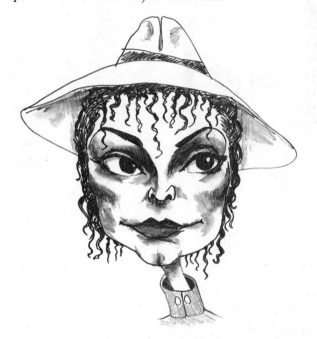

Jimmy and Tammy Faye Bakker (no longer a couple, but they'll be forever together in our memory) both have broad faces, but I chose to widen his considerably to accommodate his perpetually benevolent grin, which contrasts with his small beady eyes. With her I chose to utilize a squared-off pear shape for her head, and of course the obligatory but necessary (and helpful) spider eyelashes, generous mouth, and overdone makeup.

I did this drawing of Michael Jordan because of his unusually shaped head, strong jawline, and ears that seem to go the wrong way. His flat nose, charming smile, and small eyes complete this humorous portrait.

Andy Griffith is not an easy caricature, because he has regular, even features; his mouth, nose, and eyes are subdominant; and only his shaggy brows, dimples, distinctive hair, and low hairline are dominant.

Bill Cosby has large, expressive eyes, a broad, flat nose, and a mouth with an exceptionally full upper lip. His is one of those faces where all of the features make a contribution and all have to be dealt with. We can't play down any aspect of his face.

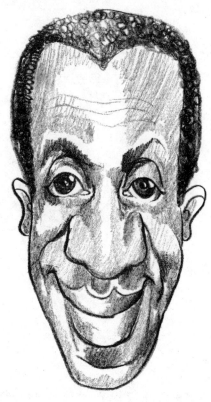

You can't do a caricature of Barbra Streisand without accentuating her nose; however, you can't ignore her flowing hair, large, expressive eyes, and distinctive mouth.

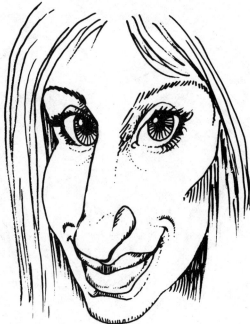

Einstein is fun to do because he's such a wonderful mass of wrinkles and curves. I chose to continue that theme in his hair by exaggerating the waves and curls.

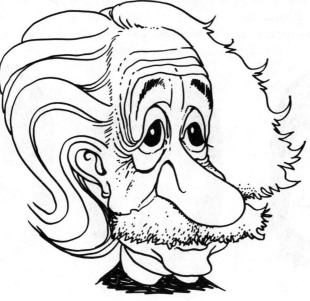

Siskel and Ebert are also thought of as being inextricably linked together. They've always reminded me a bit of Laurel and Hardy, not just because of the obvious fat-thin thing but because of their slightly combative attitude with each other, so I chose to give them Laurel and Hardy derbies just for the fun of it.

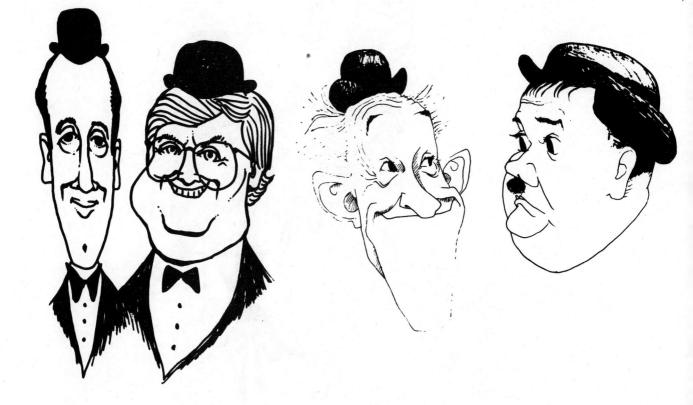

These four faces are very well known, but still their grouping helps us recognize them. John's narrow face, distinctive hairdo, pointed nose, and granny glasses make him a fairly easy target. George's wide-open creased smile and continuous eyebrow and Ringo's sad hangdog look make them easily caricaturable. But Paul's absence of strong features and his "cuteness" make him much more difficult to capture.

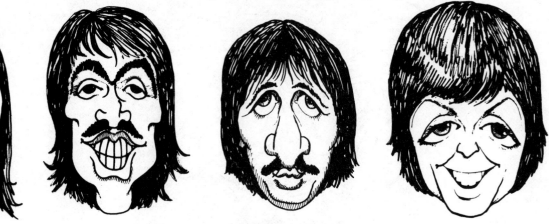

Mark Twain is fairly easy to do. He has an attitude, first of all, a saltiness of expression that helps enormously. His mustache, mane of white hair, and cigar are also of enormous help.

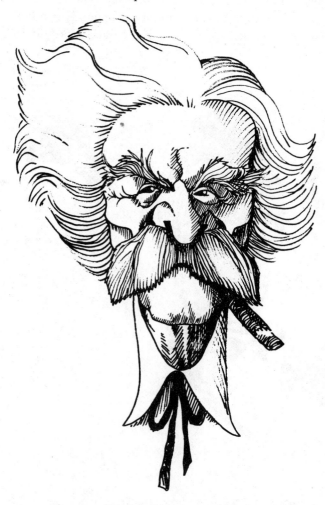

C. Everett Koop is wonderful to caricature. The beard alone is a godsend. Look at this drawing and then list what you consider to be his dominant and subdominant features.

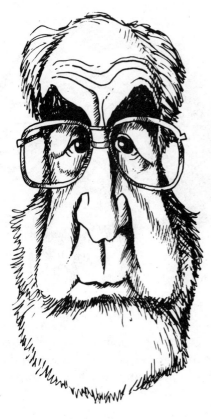

Willie Nelson has a ruggedly interesting face, but frankly I got a lot of help from the pigtail and headband. These kinds of instantly recognizable props are very useful.

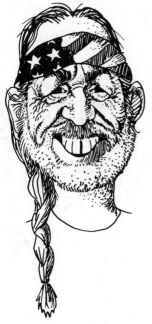

I dipped back into the movies of the 1930s and 1940s for this familiar face—one of my favorite character actors of all time, Peter Lorre. His large, expressive eyes and slicked-back hair make him a perfect subject.

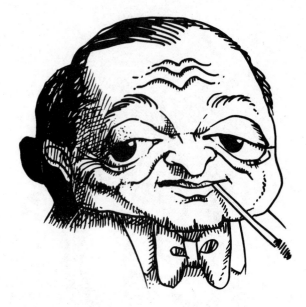

Omar Sharif's large, wet eyes, gap-tooth smile, and curly gray hair are definitely the dominant features here; his nose and the shape of his head are relatively unimportant (although everything is important, we're just trying to assess these things harshly).

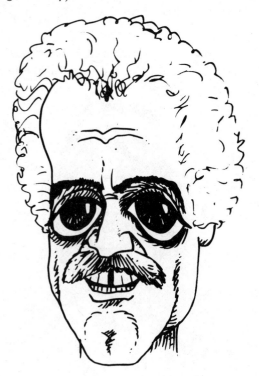

Buddy Hackett's crooked countenance makes for a fun caricature. He has small, dark eyes and a round nose. In fact, for the whole overall picture, think round.

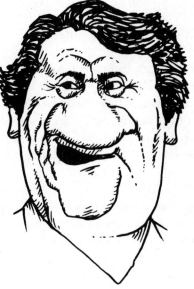

For several reasons, women are harder to caricature than men. First of all, their faces are softer and less angular, and they wear makeup that softens and improves their appearance. Women are more sensitive about caricature, and with good reason. Our society has always imposed stricter standards on women and their beauty: their attractiveness or lack thereof is more of an issue because of our cultural biases. Their place in society is often measured by their beauty. Consequently, I find myself going easier on women subjects.

I tried to tread a fine line in approaching this likeness of Sally Jessy Raphael. I leaned heavily on her glasses, her wide mouth, and her small, expressive eyes.

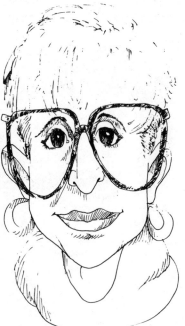

As an exercise in caricature, let me recommend sitting in front of the TV set and quickly grabbing the ''essence'' of the faces that appear there. Sometimes they appear only for an instant, but try to see how much you can retain and use from those faces. What was the thing that first impressed you? The head shape? The hair? The nose?

If I'm having difficulty with a face and I want to get a fresh perspective, I turn to another device. If I'm working from a series of photographs and I've grown too close to them, I turn them facedown on the table and then one by one turn them over and instantly draw what I see without planning, analyzing, or thinking. It forces me to quickly seize upon the obvious, vital aspect of that face, the one that had been eluding me because I was becoming too familiar with it.

The other thing I dread as a caricaturist is someone with features that are too even—that is, too attractive or handsome. Such features are often tough to snag. If a face is pretty and exotic, you have somewhere to go; if a guy is ruggedly handsome with some craggy lines, you can deal with it; but when a face is just nice-looking (maybe I'm really saying bland), it poses a real problem. What I usually do in this case is to spend more time on the drawing and be quite painstaking in my approach. In these cases I often retreat to the *''portrait chargé''* form; it's better for people with this kind of face.

Here are a group of caricatures that I've done from photos, or from observations of people in restaurants, airports, waiting rooms, and doctor's offices, on boats, etc. Some are my family, some my friends, along with a liberal helping of strangers. If you happen to see yourself in here, please don't sue me. After all . . . can't you take a joke?

You can see that with this face I chose to accentuate the broad expanse of forehead—remember my previous remarks about not ignoring the cranial mass? I also seized upon his down-turned eyes and curly hair.

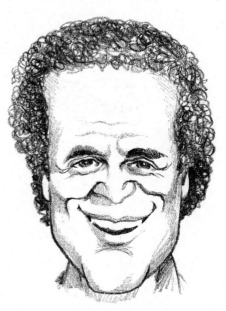

This man is all pale creases and smiles. The absence of eyebrows is of great help in achieving this resemblance.

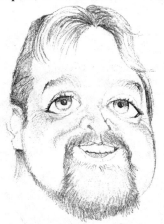

Here's a case where the head shape is enormously important. Start with a pear, use the beard and the large eyes, and you're nearly there. The hair parted in the middle is helpful, but the nose and ears are undistinguished.

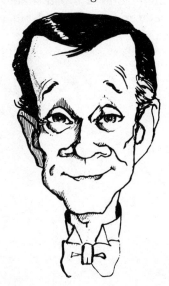

With this man's face I had to stress all of the elements in order to achieve a likeness. The head shape is fairly standard, but the wide nose, large wide-set eyes, small thin-lipped mouth, prominent ears, and distinctive hair all combine to capture this most interesting face.

With this woman's face the head shape was vital; the glasses were a key item, followed by the prominent nose and hairdo.

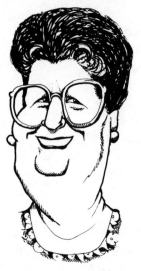

In this drawing the nose is the major dominant feature. Once that was realized, the crinkly eyes, mustache, and jaunty cap, combined with a few fleshy neck folds and gray temples, complete this caricature.

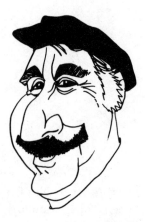

This woman's face posed a problem in that none of her features was oversize or unusual, but the combination of broad smile and narrow eyes provided an interesting hook; her caricature turned out to be a series of extreme angles.

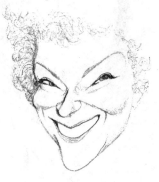

Another dominant nose merging with a pair of small, knowing eyes, a slightly receded mouth, and a double chin all aided in this drawing.

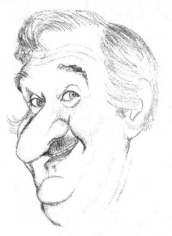

Here's another drawing born initially of the head shape. Next the eyes were captured, then the beard and hair. The ears protrude a bit, but they're not critical. The nose is definitely a subdominant feature.

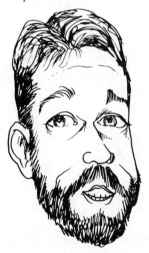

This face has no particularly outstanding features, but the mustache, bald head, and ingratiating smile gave me the key.

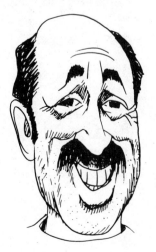

In this case I had a wonderful nose to work with. I minimized the eyes and played with the loss of hair and the curly mane and the mustache. His chin is strong, so that becomes a real asset in completing the total likeness.

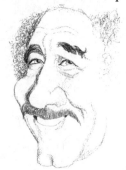

This attractive older woman's face didn't have much to caricature, so I had to rely heavily upon her glasses, her eyes, and the shape of her head. Her white hair was a help, but as I mentioned before, people with fairly even features are a real challenge to the caricaturist.

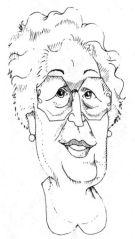

Again I was faced with a wonderful nose. Here I chose to actually bury the mouth beneath the nose in order to accentuate the hook, and I had fun with the eyes, creases, and dual-colored hair.

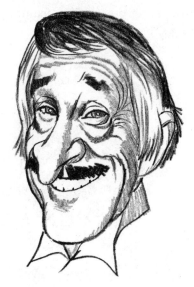

Here's a good example of a dominant cranial area, which along with the large glasses, protruding ears, weak chin, and beaming smile produces a rather effective drawing.

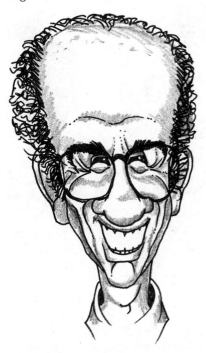

This long narrow head and long narrow nose contrast nicely with the wide-set, expressive eyes and little crew cut.

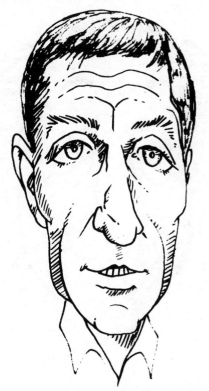

Here's a sketch of an interesting face, which I'll take into a mild caricature. . . .

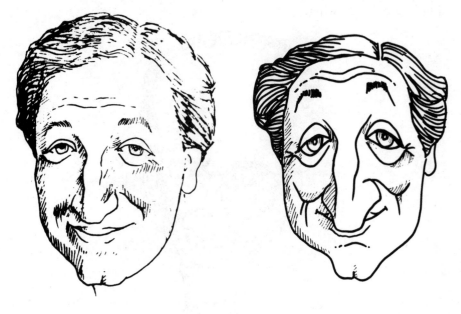

What I did primarily was to accentuate his nose, tuck the small mouth beneath it, and zero in on a pair of sad blue eyes with small brows. Then I accentuated his particularly odd hairstyle and shrank his forehead.

Let's move him another step to a slightly broader version. . . .

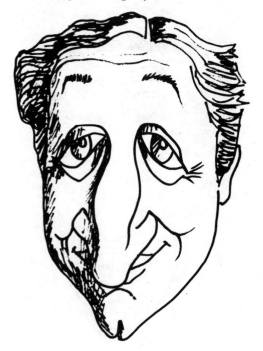

And finally downright bizarre.

The trick in taking a caricature this far is to constantly monitor yourself along the way to make sure that you haven't lost sight of the all-important resemblance. There's a tendency while you're exploring like this to fall in love with the outrageousness of your own drawing and possibly sacrifice recognizability.

To wrap up this chapter let me say that, much like the highly skilled rodeo clown who performs daring feats or the comic diver who risks his life going off the board, the humorous artist has to be familiar with and understand all the same rules as does the artist seriously dedicated to representational, true-to-life drawing. Burne Hogarth, in his excellent and meticulously realized book *Drawing the Human Head,* states that "the art of caricature needs an exacting fund of information with which to play out the extremes of exaggeration and grotesquerie." The successful caricaturist also needs a dash more vision, a wild imagination, and a sense of humor all interwoven with a deep understanding of human nature. If this sounds forbidding, it's not. I'm merely trying to impress upon you the fact that caricature is art and should be approached accordingly. As Aldous Huxley said, "Parodies and caricatures are the most penetrating of criticisms."

CARTOONS

As we enter the world of cartooning, keep in mind that although the cartoon is an even further distortion of the human face, it still must be kept on a fairly tight rein. In cartoons, unlike caricature, where retaining a resemblance is necessary, you can be as bizarre as you wish and go as far as your imagination can take you. However (there's always that *however,* isn't there?), there are still those few rules to which you must adhere. You have to cling to that internal sense of proportion, and you have to work within an overall sense of distortion ruled by an intrinsic sense of design.

Try to think of cartoons as living, breathing things; after all, you can take only so much license with the human form. In viewing a film we all indulge in what has been called ''willing suspension of disbelief,'' and it exists likewise in the world of cartoons. We all realize when viewing an animated cartoon or looking at a cartoon drawing that human beings could not possibly look that way unless they were total grotesqueries; still, we go along with it, and accept it for the sake of our amusement. But if you stretch those lines too thin and lose too much resemblance to the human form, you've crossed over into a world of nonrepresentationalism.

To begin with, cartoon faces can be any number of shapes, way beyond that of the mere oval. Here we have the choice of using a square, a triangle, a rectangle, a circle, a pear shape, ad infinitum. Unlike realistic drawing, cartooning allows you to concoct as many head shapes as there are hairs on a barber's floor. For instance . . .

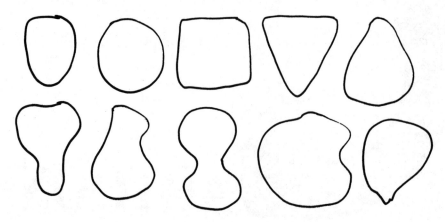

And within those various heads you can place a variety of cartoon features to produce an infinite variety of amusing characters—hence the "1,001" in this book's title. Actually, there are many more combinations than that, but we're not given to overstatement.

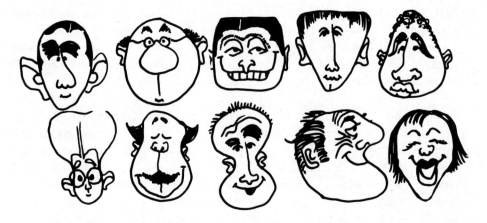

Obviously, the strict rules of drawing and portraiture don't apply to cartoon features either. Here a nose can be devoid of nostrils and cartilage, it can be as sharp as a knife, as bulbous as a melon, or as droopy as a spaniel's ear. You have the latitude to create all the variations of noses that you possibly can.

And the same with eyes. They can range from a simple dot or a slash to a more completely realized eye.

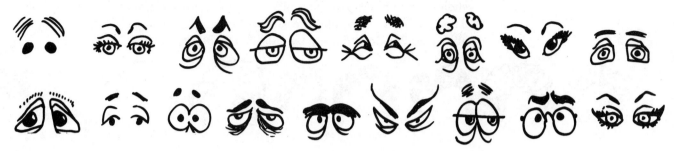

And again, as in portraiture, be aware of where you place the pupil to make the eye sinister, sneaky, or suspicious.

Mouths come in a wide variety of shapes and sizes, and they change shape constantly as we talk, eat, yell, pout, yawn, sneer, and cry.

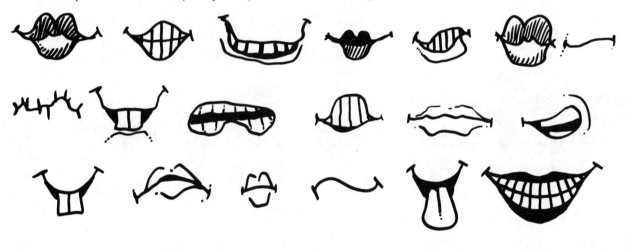

Ears have fewer variations, but play around with them anyway and see how many different shapes you can come up with; you'll be surprised. Also consider using other objects for inspiration, things like plates, airplane wings, cups, leaves, etc.

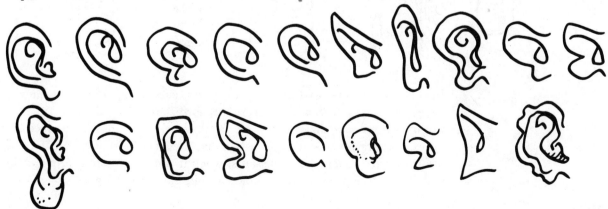

Hair plays a significant role in the overall look of a character. The choice of hairdo or haircut is an extension of the personality, much the way the choice of clothing or automobile tells you something about an individual. The hair is the frame and the face is the painting; you can cause a remarkable overall change merely by choosing a different frame.

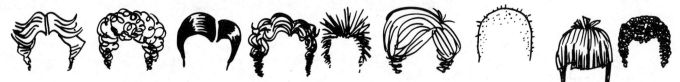

Let's take a rather generic woman's face and frame it in several ways.

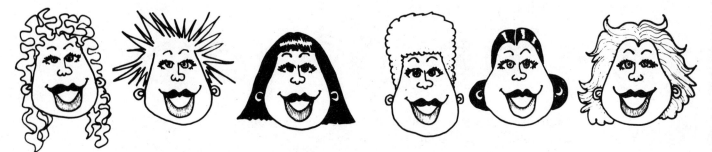

Today the male (at least the young male) has almost as many choices of hairstyle as the female, and if you want to include military styles, crew cuts, and skinhead looks, possibly even more. Here's the tip of that iceberg:

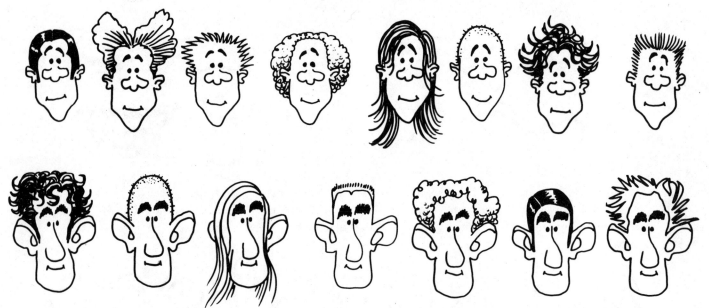

In order to produce a variety of eyes, noses, ears, hair, chins, or whatever, we have to begin with a different shape, form, and contour. Sometimes the inspiration for that shape can come from a variety of unusual sources. For noses, conjure up an image of a banana, a zucchini, or a spoon; for eyes use teardrops, squares, or croissants; when it comes to mouths any opening will do: a craggy cave, a keyhole, a coin slot. For hair use steel wool,

spaghetti, or anything else that comes to mind. The idea here is not to think of the feature primarily, but to conjure up an object and turn it *into* a feature. It will free up your imagination and set you on the road to creating unusual and diversified characters.

Now the trick is to fuse all of these elements into a cartoon whole, remembering we must incorporate correct placement. They are not nearly as stringent as portraits, but cartoons have to obey a certain number of rules to achieve the level of proficiency I'm sure you are seeking. Here's where the creative fun comes in, the freedom to experiment using good old trial and error until you find that unusual or fitting feature for the face that you are concocting.

To begin the cartoon head, use an oval, much like the one used in portraiture. But here we have the latitude to place the line for the eyes above or below the standard mark.

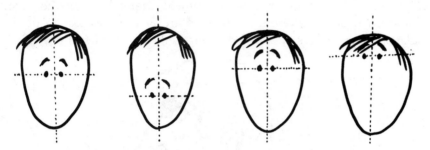

Even though it is a cartoon, the spatial relationships still have to make good visual sense. Here's a cartoon that is ineptly drawn. But why? For one thing, the facial area is too filled with those large eyes and that wide mouth. You need open space, or "air," in the drawing. This is too crammed with features.

Here are several examples of cartoon faces with attention paid to the integration of features within the face.

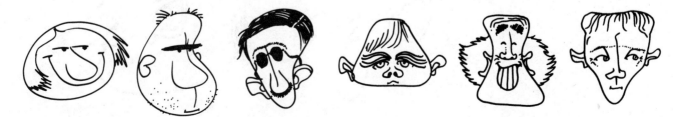

So you see cartooning has its traps and pitfalls also. You don't have total license for distortion; it has to be controlled and thought out. Here's another common error perpetrated by the amateur cartoonist. Do you see it?

Of course, it's that infernal ear placement again; even in the relatively unfettered world of cartoons, if the ears are placed too close to the face it looks peculiar. Here's the same drawing with the ear placed properly.

In cartooning you have to achieve selective distortion. Of course, as with any rule, there are exceptions. When you become adept enough at cartooning you'll be able to break, bend, or generally get around these rules. For example, if you were to draw a character who was extremely thin in profile, you could place the ear forward or way toward the rear of the head and it would still work. The same doesn't necessarily hold true with a more rounded face.

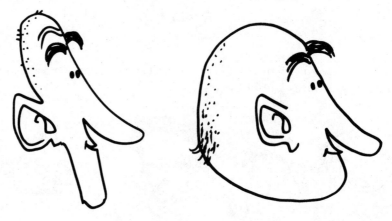

Difficult to say why, isn't it? It just doesn't look or feel right; it's off balance. It doesn't sit right with that internal grid. Now I know I keep harping on spatial relationships, but they're important here, also. They have to have mutual respect for one another; they have to share a very small area and still try to make artistic sense out of it. Think of it as spatial cooperation.

Just to see how much difference the head space makes, let's take a set of features and put them in various head shapes.

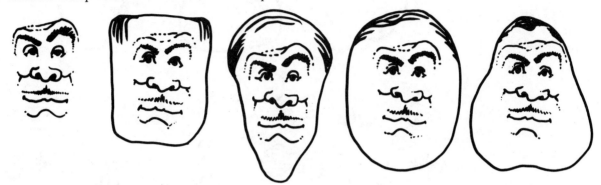

Now let's return to some basics in order to determine where the features are placed. It's still a good idea initially to use the sectioning-off technique that we used earlier. Divide the head in half vertically, not horizontally, and then place your features inside.

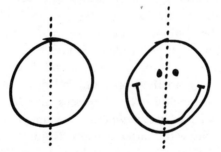

Observe this triangular shape with various noses placed at different levels within the face and see how it changes the look. Also note that the eyes and mouth have remained the same; only the noses and their placement in the face have been altered.

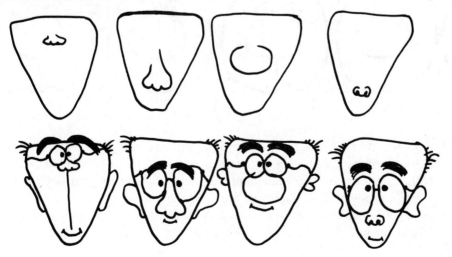

Here are a few head shapes and some features. Grab your pencil and match them as you see fit.

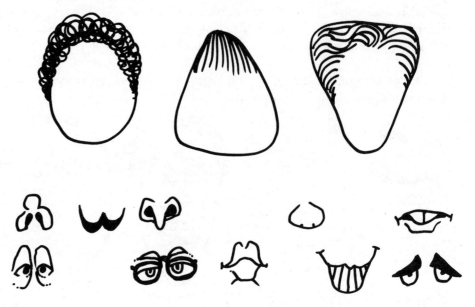

I like to shift the features within the face, experimenting until I come up with something that pleases and excites. There is, I believe, an inherently good sense of design in the successful cartoon face based upon the placement of features within the allotted area. Take, for example, this round head shape. I place a rather bulbous nose (I like to start with the nose because it's a dominant feature, but you can use whatever you wish) at this spot in the face, then I look at the remaining space and decide how to fill it or use it wisely. I chose to extend the upper lip and place the mouth way down toward the bottom of the chin. Then I reassess the drawing and look at the remaining area in order to decide whether I want the eyes to be important or inconspicuous. I chose the latter because I didn't want to fill the entire area with features. I wanted some daylight in there, because I felt it made for a better design.

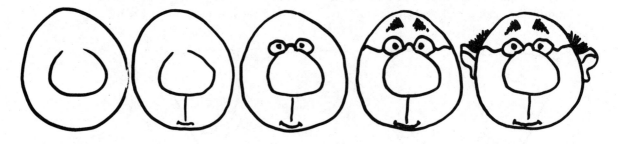

Now we can take that face, redistribute the features, and come up with an entirely different character or characters. Move them around in the grid, higher, lower, and see what happens. Start shifting and moving and distorting, subtly at first. Then, as you view the results, you'll see how far you can move that nose or those eyes before you lose good cartoon style and cross over into the area of the grotesque.

Think of it as a visual game in which you are constantly shifting and changing the furniture (features) in the apartment (area). If you don't like a particular piece of furniture (the nose or the eyes), change it and play some more until you're satisfied with the results.

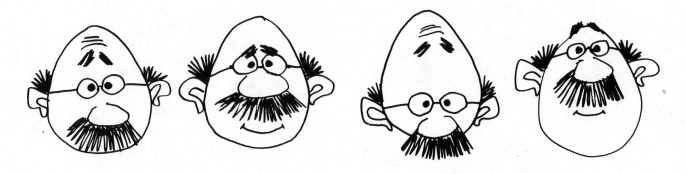

There are other rules that I've discussed in previous chapters that are also applicable here. For instance, if you want your character's head to turn, lift, or drop, apply the same principles as in portraiture—draw those center lines and don't let them shift as the head moves.

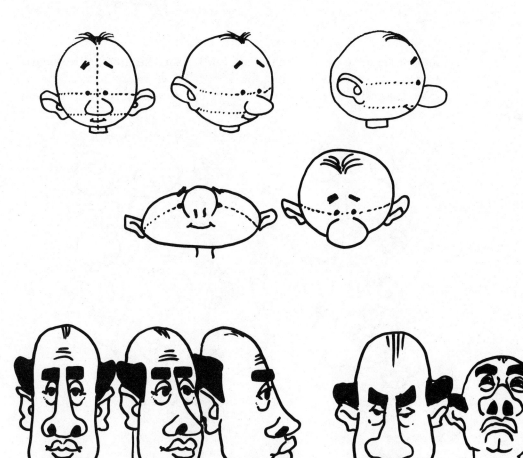

There are, however, a few things we can do in cartoons that other forms
don't allow. Like turning a profile into a full face or three-quarter with the
addition of just a couple of pen strokes. Here I drew a profile, but to turn
it into a full face all I really had to do was add on the right side of his face.
It's Picassoesque, but effective and simple.

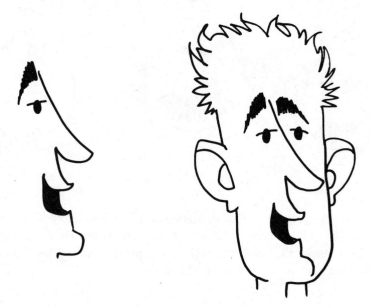

I did the same thing to this female face, but I turned her into a three-quarter
view merely by adding the line and eye that I've isolated here. Practice
these techniques; they're great time savers and they lend style to your draw-
ing.

Another exercise that young cartoonists enjoy is the challenge of drawing a group of faces in which one feature is dominant and the others relatively subdominant. In practicing this, draw the dominant feature first and let that dictate how the remainder of the face progresses. Here are several examples of the results of my doing this exercise.

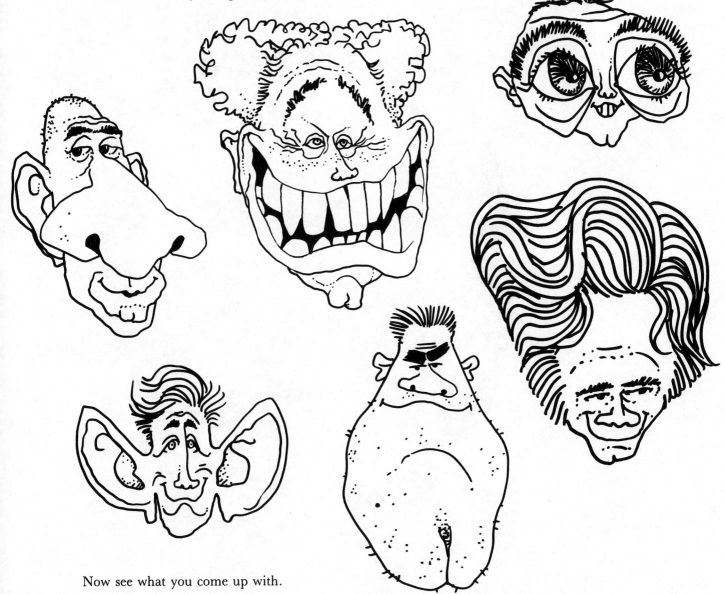

Now see what you come up with.

If you draw someone unsuccessfully, don't toss it into the circular file. Save it. Remember that today's unsuccessful caricature could be tomorrow's wonderful cartoon character.

Another thing I like to do is create faces by combining features inspired by friends or family members. Take sister's head shape and stick in brother's nose and combine with Bob's hair, David's chin, and Pam's eyes. You get the idea.

Experiment, have fun—that's what it's about.

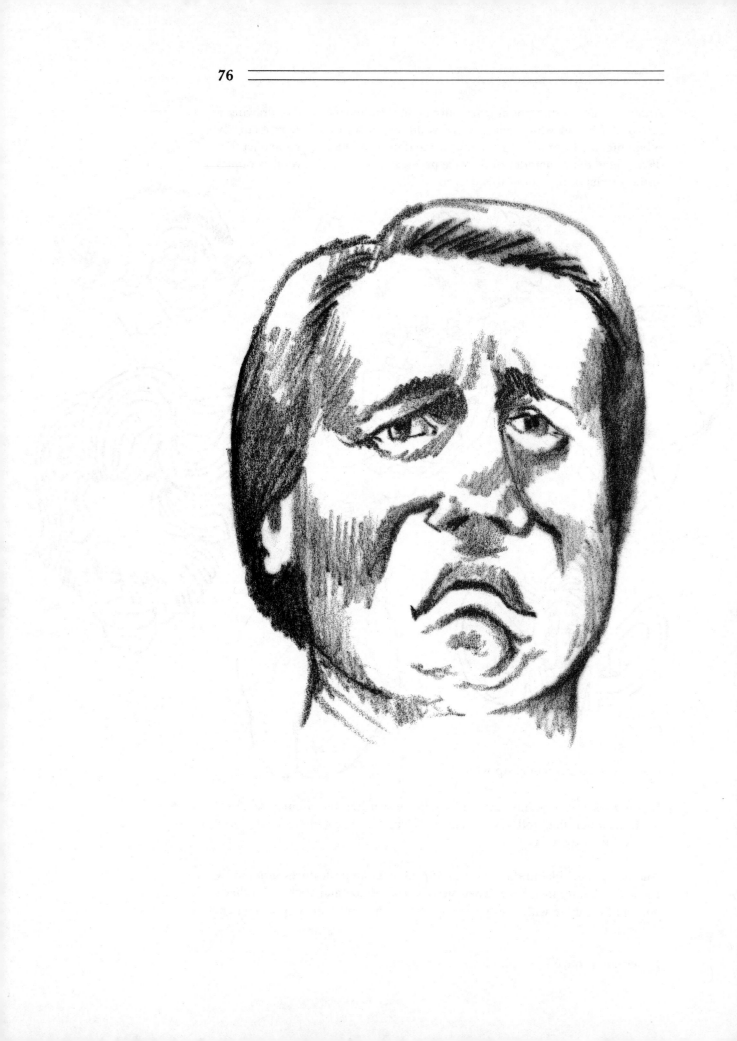

EXPRESSIONS

Through the years I've often heard a rather Pollyannaish expression that it takes "seventy-two muscles to frown and only two to smile." The sentiment is worthwhile, I guess (if directed at a particularly sour character), but the numbers are way off base. First of all, there are only twenty-six muscles that move the face, and only eleven are responsible for facial expression. Without getting into those long technical names like zygomatic major or risoriis/platysma, suffice it to say that these eleven muscles are responsible for the six basic facial expressions: anger, disgust, fear, joy, sadness, and surprise . . . and a slew of subtle variations of the above, such as jealousy, suspicion, doubt, smugness, glee, hysteria, etc.

Expressions appear involuntarily (except on the faces of bad actors), because the emotions send a message to the brain, which in turn relays the message to the face, which then frowns, smirks, winces, smiles, or whatever is appropriate. No one teaches us these expressions; they're merely part and parcel of the great mystery of physiology. Expressions are the only (save possibly music) universal language. No one teaches a child's lower lip to quiver prior to sobbing, and people are not taught to bury their heads in their hands in moments of grief or bare their upper teeth in a grin. We just do it. Films with little dialogue are successfully exchanged from country to country; even the most primitive and sheltered of tribes, once having gotten used the concept of film, are able to read the same basic emotions as does the most sophisticated filmgoer. How many people can look at this picture of Jimmy Swaggart (in one of the most famous crying scenes in recent memory) and not know what he's feeling?

I believe that the artist's best source of inspiration for expressions is the mirror, but if you can't take that (some artists I know get strangely self-conscious mugging at themselves), go to magazines and books. You'll be able to find any expression you want if you're diligent.

Facial expressions can be divided in half: the upper portion involves the eyes and brows, and the lower portion the mouth. Those are the main areas we'll be dealing with. Nothing much else happens, save an occasional crinkling of the nose, an occasional jutting out of the jaw, or a pulling down of the cheek muscles. But primarily it's the eyes, mouth, and brows.

I stared at myself in the mirror (a not uncommon exercise for an actor) and did a series of quick sketches of the following basic expressions: anger, disgust, fear, surprise, sorrow, and joy. Let's tackle them alphabetically (just so I don't reveal any latent psychological partiality), starting with anger. With this emotion the mouth turns downward or remains set in a stubbornly firm line while the eyebrows and eyes combine to produce a glare, a look of extreme intensity. The head will sometimes lower so that the eyes peer from beneath the brows threateningly.

Disgust is shown through the wrinkling of the nose and the curling of the upper lip, as if one were smelling something rather unpleasant.

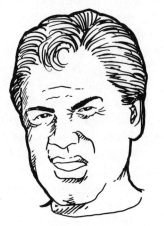

Fear and surprise both cause the eyes to widen while the jaw drops help-lessly. With fear, however, the eyes widen more, so more white is revealed around the pupil. Here's surprise.

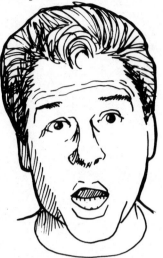

And here's fear. You can see that the difference is minimal.

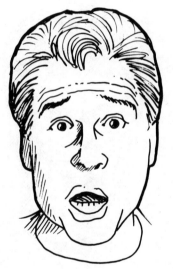

Here's a more caricatured version of fear. The expression seems stronger given the more extreme treatment that caricature and cartoons allow.

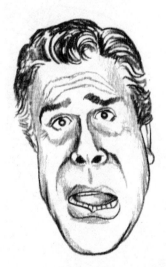

The eyes widen a little when demonstrating joy. The lower half of the face brightens; the mouth opens and turns upward at the corners.

Calm down the eyes, show less white, and the expression turns benign.

When sorrow falls upon us, our mouths purse and curl while the intricate network of muscles around the eyes squeezes tightly together.

Of course, there are many more expressions than we have touched upon here, like concern, which is an offshoot of anger.

Here's a sketch I did of myself in pain.

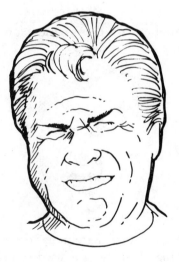

Here's a sheepish or guilty look.

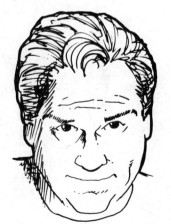

Different faces do different things with the same expression. Here are three manifestations of happiness. In one the teeth show, in another the eyebrows lift, and in another the eyes crinkle almost shut.

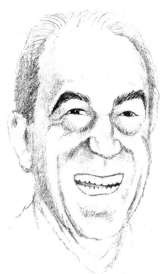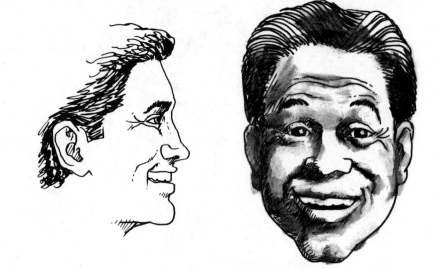

There are so many variations on these basic expressions. Anger can turn into rage, for example.

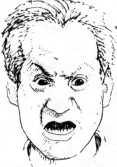

There are certain expressions that share upper or lower muscular activity—for example, the crinkling of the nose is used in disgust as well as in rage and occasionally in laughter. (The ''cute'' nose crinkling that coy types use to punctuate their conversation we'll not go into here; my doctor advised me to avoid sugar.)

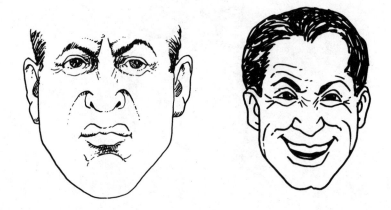

And occasionally that nose crinkling is used in yawning.

Curling of the upper lip is employed, ironically enough, in both laughing and crying. The mouth does not always turn downward in grief (as is commonly believed), but in some people turns upward, much as it does when a person laughs.

Surprise, fear, and amazement all employ the dropped jaw in varying degrees. It's the upper half, the eyes, that makes the difference. Here's a pair of eyes going from "neutral" to thoughtful, and then registering suspicion and finally fear.

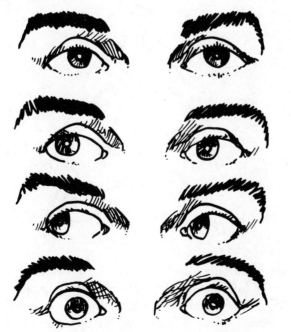

The human face can suggest many subtle emotions, but often we read something into the situation, anticipating a certain reaction or tone of voice from a person. In drawing, as in the art of pantomime, everything must be communicated visually. If you finish a drawing and you're uncertain as to whether the proper emotion is communicated, test it out on friends and see if they nail it right away. There's no better barometer of your success or failure.

We apply the same basic principles to cartoons, but in this case the expressions can be greatly exaggerated. The facial muscles know no bounds, so a smile or a laugh can wrinkle and distort the face, producing an exaggerated but very clear emotion.

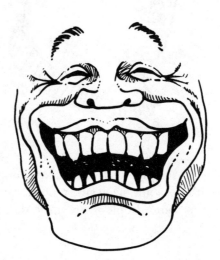

And the same applies to crying.

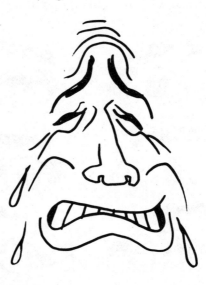

There are many combinations of upper and lower muscular activity that make up a slew of intermediate expressions. Try to break these down to see how they work: What muscles were brought into play? What are the eyes doing in conjunction with the eyebrows, the lips, the mouth, the forehead?

Here's an evil and angry look.

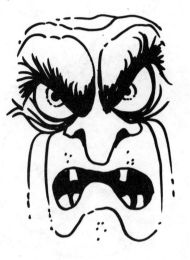

If we change only the mouth, it becomes an evil leer.

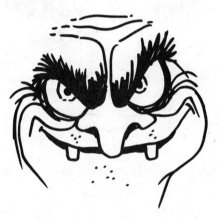

This expression of sheer enjoyment turns a bit cruel when the angle of the eyebrows changes.

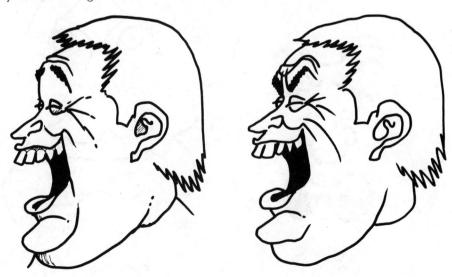

In cartoons we're allowed to distort the mouth and add as many wrinkles as we want to help sell the emotion, as long as they make some sort of physical sense.

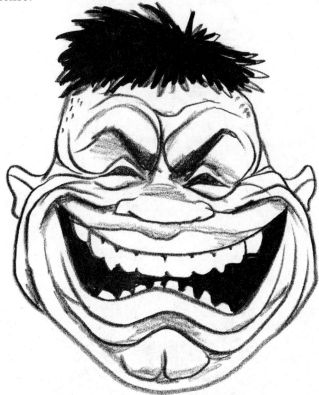

It doesn't require much attention to detail to convey an emotion.

Petulance Anger Embarrassment

Threat

Panic

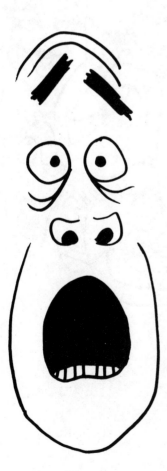

Horror

Apprehension

Shock

Now that we've completed this chapter, do you know what's going to happen to you? You're going to become so much more aware of what happens to the human face that you'll suddenly find yourself staring at people clinically, analyzing exactly what their faces are doing. You'll be keeping an eye out for that worried-looking corrugated brow, that tiny hesitation of wrinkles around the eyes, that slight indentation about the mouth as it registers the slightest hint of disgust. In short, it will make you a better reader of emotions; you will be increasingly tuned in to the slightest change in the faces of your friends and family. It could be a gift or a curse, depending upon circumstances, but remember what I say: you'll never look at anyone in quite the same way again.

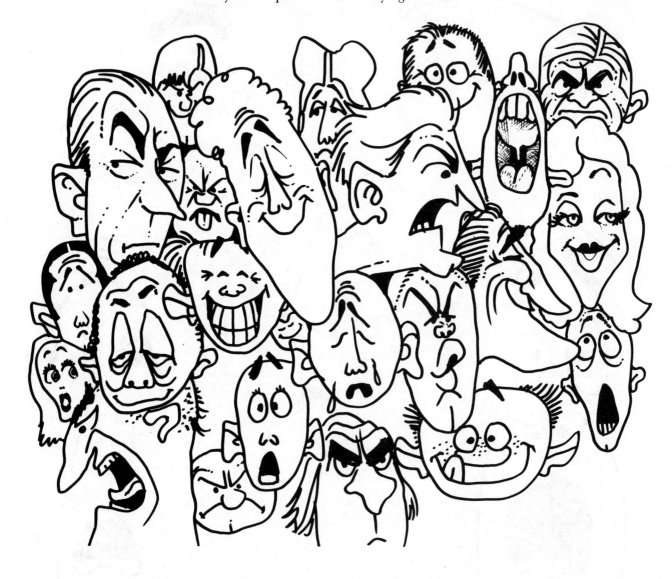

CHILDREN

Children's heads and features are rather amorphous. They are so unformed that doing a portrait of them is more difficult than dealing with an adult face. There are no wonderful craggy wrinkles or strong noses to catch, no interesting angular lines and deep shadows. They're all rather soft and round, and their features flow into one another.

When a couple show off their newborn to family and friends, someone will inevitably say, "He looks just like you, Bill," or "Peggy, he has your nose." In truth, he has a tiny button of flesh that's bound someday to become a nose, but for the moment, no nose. All babies, children, young-sters, tots, boys and girls alike, share some facial characteristics: their heads are large for their bodies and their cranial mass is bigger than the facial area. This is for a very good reason, of course—since they are not quick to shield themselves from harm (not having yet learned what's out there to get them), they need additional protection for their delicate heads (that God guy is so clever, he thinks of everything). So when sketching the dimensions for a child, remember that the cranial mass is consistently more prominent.

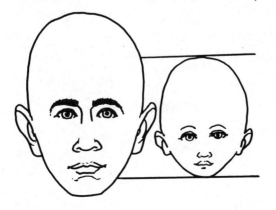

Children's eyes appear larger and their lashes longer (the eyes remain approximately the same size all during childhood and maturity), their cheeks are fuller and rounder, and their mouths are smaller (the upper lip is quite prominent and protrudes, especially in babies).

Children's eyes appear to be set farther apart than eyes in the adult head. The hair is fine and the eyebrows extremely light. Their noses are upturned and the ears appear larger proportionately. The neck is slimmer and the back of the head juts out farther.

Dig out some old pictures of yourself when you were a child. Note how your head looked larger, the eyes bigger and more wide-set. Then compare the photos with what you look like today and see how the maturation process has shifted the balance between the upper and lower sections of the head.

Doing a portrait of a child requires an astute eye; you have to seize upon the most subtle facial irregularity in order to capture a satisfactory likeness. Here's a sketch of a boy at eight years old; he still has the larger cranial area and full cheeks (called "baby fat" in some circles) of his age group.

But as he grows to age ten or thereabouts, the lower section of his face grows to match his cranial area, producing a slightly more mature appearance. The baby is gone; the young man is waiting in the wings, ready for his entrance.

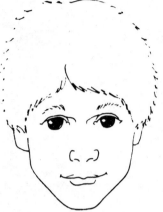

A couple of years add to his more mature look as his cranial mass seems to shrink. Actually, his face is just filling out and growing longer—in effect, catching up with his head.

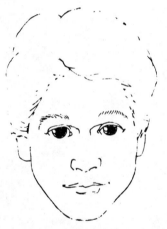

And here he is on the brink of manhood. His features have almost completely matured, and his face has reached its maximum size (save additional weight gain).

Here's a boy in that in-between stage just before manhood, that quasi-independent painful state that we all go through, the terrible early teens.

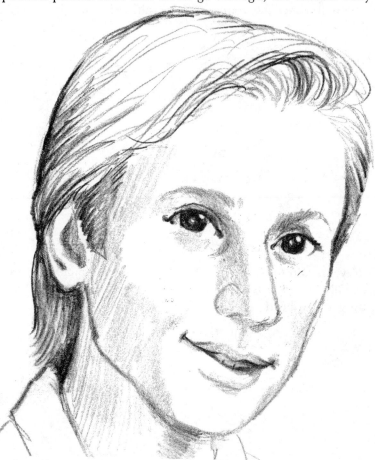

This girl has an unusual quality. Her heritage could be Polynesian, and that accounts for the slight flattening of her nose, the long straight hair, and her almond eyes.

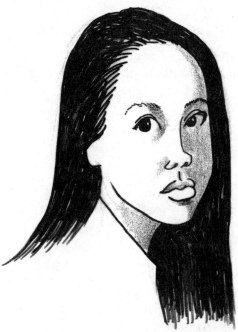

Here's a boy with interesting features: his nostrils flare slightly, his ears appear almost inverted, with the heavier area at the bottom, and his eyes have a very subtle upward tilt to them.

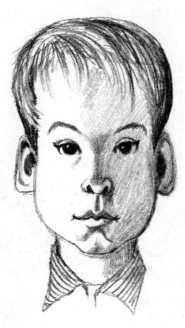

This young man reminds me of a typically American "Huck Finn" look, complete with red hair and broad grin.

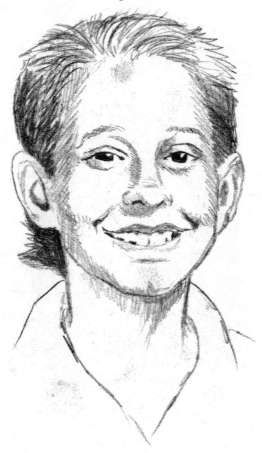

This young lady, obviously in her mid-teens, possesses a faint Latin flavor. I emphasized her large, expressive eyes and full mouth, along with her dark hair.

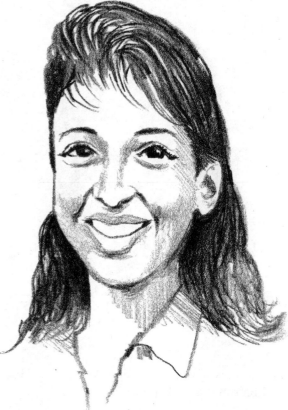

Here's a young girl with strong features. Her slightly upturned eyes, large ears, and full mouth and that mass of curly hair make her easier to depict than most girls her age.

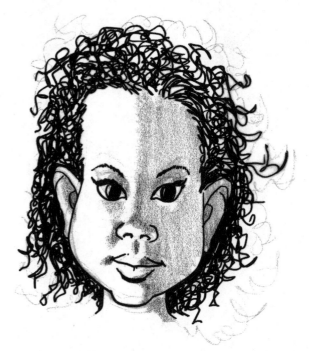

In caricaturing children the same rules apply. The larger cranial area dominates the facial mass, as in these two humorous portraits.

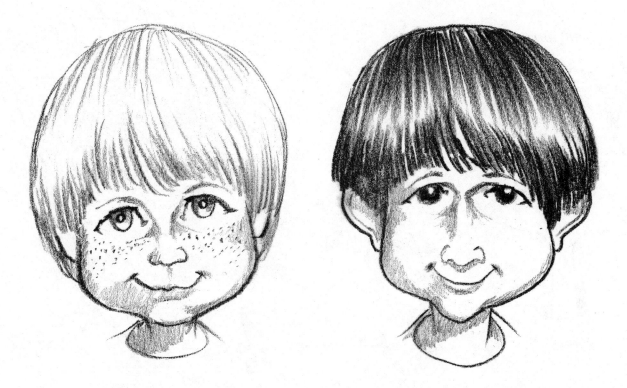

In the world of cartooning there's a lot more latitude, but the viewer must still recognize instantly that this is a child. In Charles Schulz's classic *Peanuts* strip, the children all have very small bodies, large heads, and dominant craniums. An easy way to suggest ''child'' is to have the face occupy only one-third of the head.

Here's a wide variety of cartoon children to give you an idea of how to introduce interesting and different looks and personalities in spite of the limitations.

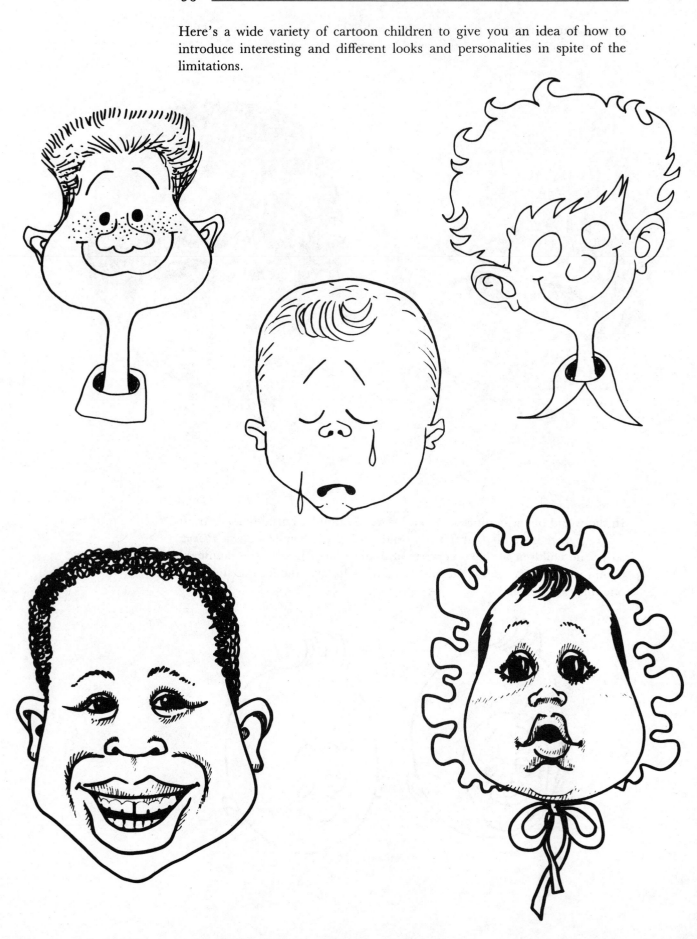

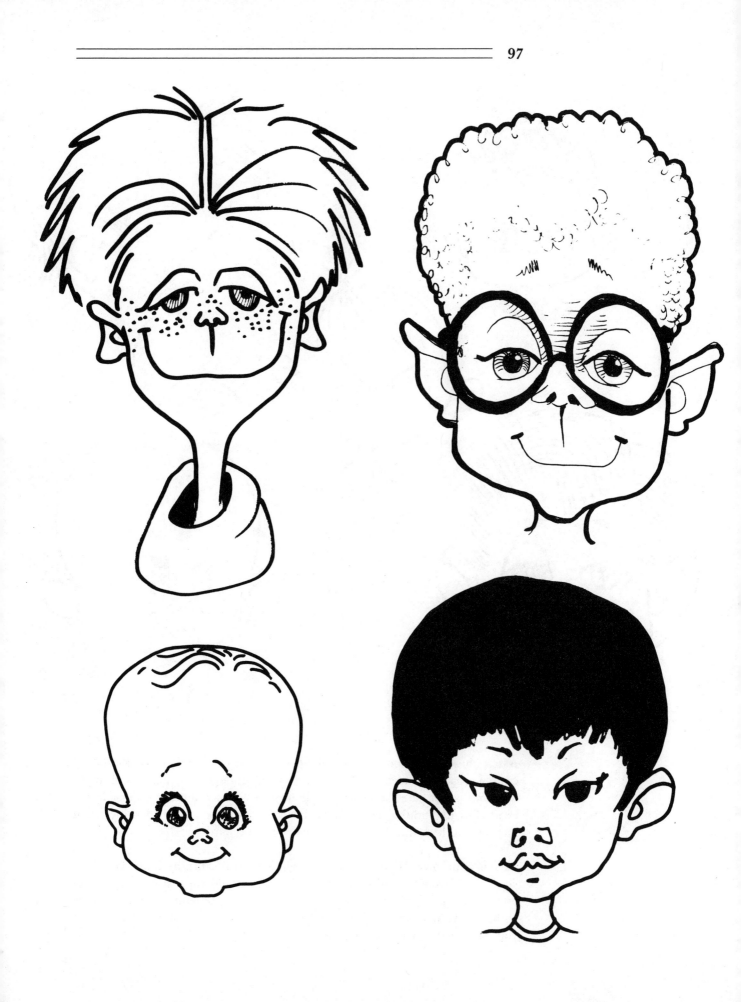

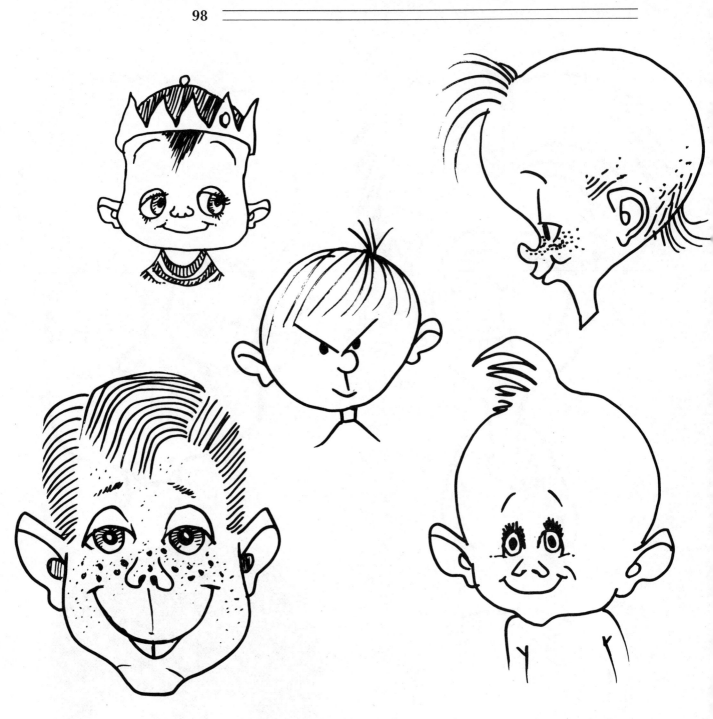

Assess these faces and find the obvious common denominators: the larger cranial area, full cheeks, wide-set eyes, small undeveloped noses, full upper lips, and larger ears, and the faces themselves, which appear smaller in the head. But like adults, children do have their own physical identities; you just have to look a little closer and work a little harder.

Sketch your own children, your neighbors'; it's quite a challenge, since you'll have trouble getting them to sit still. I would suggest shooting a roll or two of super-high-speed film so that you have something you can work with. Use your pencil measurement technique; it's invaluable here, because you have to deal with the most subtle facial variations.

AGING

The process of aging, apart from the obvious addition of wrinkles, consists of a gradual shrinking away of the upper facial regions as the cranial mass decreases in size, and a heavier look in the lower area as the facial mass begins to dominate. Of course, added weight is one of the contributing factors, but even without weight gain, the loss of hair in men causes a visual imbalance that makes the basic form of the face almost inverted as compared with its earlier shape.

Aging is evidenced by a series of small (at first) wrinkles, combined with hair loss, the addition of glasses, new irregular hair growth (like that in ears and eyebrows), muscle sagging, and some weight gain. The trick is to know how far to go with these elements. The trap, as I see it, with new artists is that they'll draw a forty-five-year-old man with the wrinkled skin of an eighty-year-old. They don't yet know how to use restraint in the creases department, so they (much as a young, inexperienced actor, trying to play age fifty, starts shuffling and wheezing about the stage like a senile ninety-year-old) just go too far. The aging process is slow and gradual (thank God, otherwise our hearts couldn't take it) and the artist's rendering of age must take this pace into account.

Let's take one young man's head and age it gradually. He starts out in his twenties and ends up somewhere in his eighties.

The creases first manifest themselves at the eyes and the brow and around the mouth, and his chin gets slightly heavier.

Dimples, attractive in youth, can gradually become full-blown creases. The hair might thin out, and the lower jaws take on additional weight. Soon they'll qualify as jowls.

Glasses make people look older (despite all the slick ads to the contrary); the creases deepen, the bags under the eyes get fuller, and the eyes take on a slightly tired look. Here's an example of what I mentioned earlier: the masses have shifted. Where before there was a triangle, now we see more of a pear shape, as gravity does its darnedest to pull the facial structure down, causing it to sag.

The last stages of aging yield a withered, wizened look, reflecting how time has chosen to ravage this particular individual.

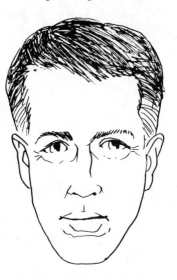
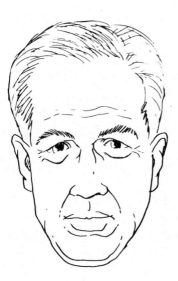
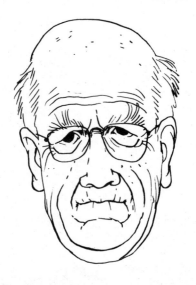
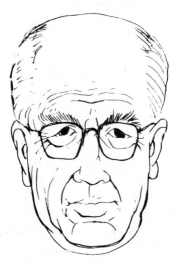

The female aging pattern is similar, although the baldness, of course, is usually not a factor.

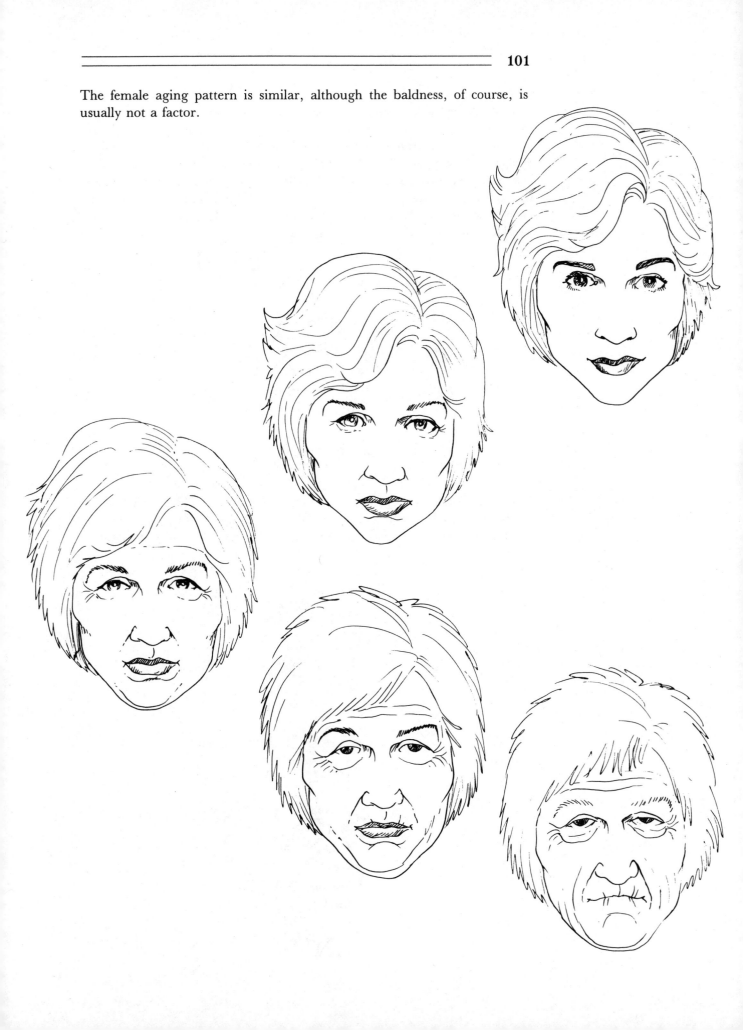

The greatest mistake made with wrinkles is in not adhering to basic wrinkle patterns as opposed to random creases. The skin's attachment to the skull causes a crease to form in certain areas. As with laying a piece of upholstery fabric over a chair frame, there are physical laws that cause the material to fold at a given point. The skull's shape dictates the wrinkle pattern. For instance, people with full brows with little variation tend not to have brow wrinkles as much as people who have a deeper indentation in that area. Facial skin loses its elasticity as we age, so it's more likely to crease, causing wrinkles.

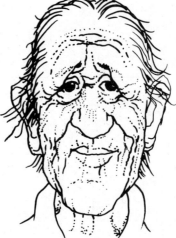

The eyes, mobile as they are, are centers for wrinkling. The crow's-feet, or "laugh lines," as they're euphemistically called, appear in people even in their mid-twenties. They usually form a pattern much like the one pictured here.

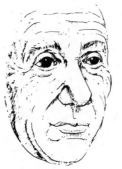

The edges of the mouth form creases that radiate outward in a definite pattern.

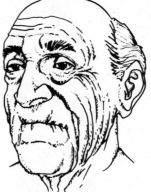

Becoming familiar with the planes of the face is vital here. It will prevent you from ever including a wrinkle or fold that doesn't naturally belong in the normal physiognomy. You'll be able to "feel" whether a face could actually fold or crease at that spot or not.

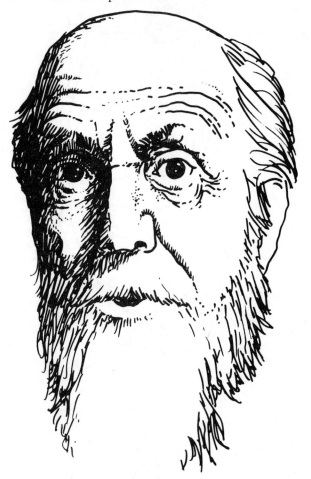

And it makes little difference whether you are dealing with portraiture or cartoons; the same principles apply. In fact, in cartoons, since the age is so much more exaggerated, any errors are almost more obvious. You can take certain liberties with wrinkles in cartoons, but they must still radiate from a given point.

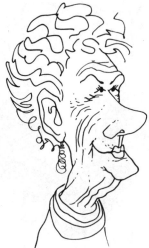

You can see how the exaggerated neck folds in this man help to sell his comedic obesity.

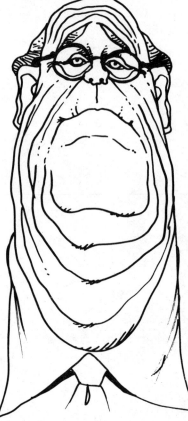

The creases around this witch's eyes and cheeks help to bring out her evil quality. But compare her wrinkle pattern to a straightforward portrait and you'll find them to be the same.

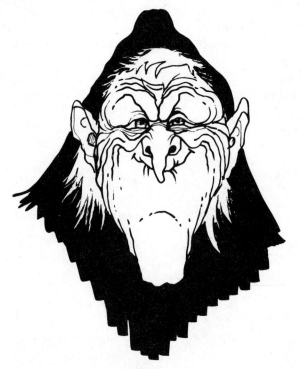

The overstated wrinkles in this happy guy's face really aid in selling his expression of sheer joy.

Here's a good example of radiated wrinkles. Follow the patterns and see how they run into one another.

You can get as broad as you wish, as in this truly silly rendering of an old man . . .

. . . or in this drawing of an old gentleman.

Then again, it isn't necessary to belabor the wrinkles in order to sell age. The contour of the aging or aged head is equally important. Despite the minimum of creases used in these drawings, you know the subjects' approximate age.

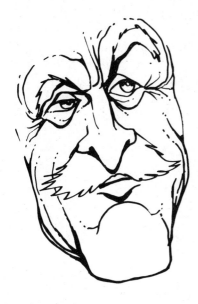

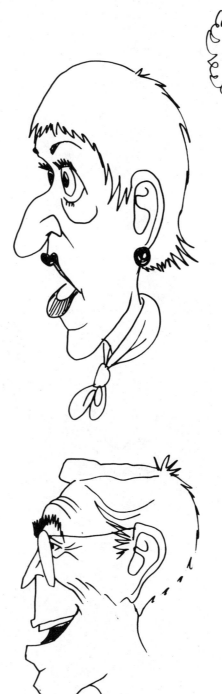

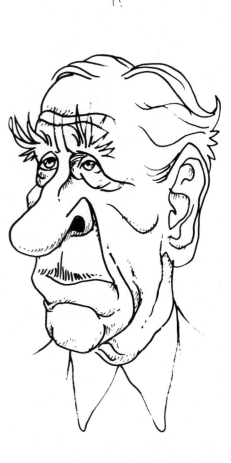

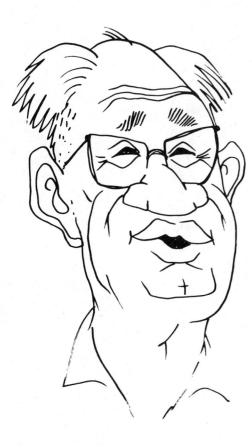

The subject of this chapter is always slightly depressing to contemplate, but becoming aware of approximately how we're all going to look at some point in the future is maybe not all bad. It does give us a positive kind of hyper-awareness that might help us to hang in with that diet for another week or so or drive us to the gym for another go-round instead of watching that *Honeymooners* rerun for the twenty-ninth time. Also, let me caution you that age is a sensitive area with some people. If you're drawing a cartoon you can go full out, no holds barred; however, in portraiture and/or caricature, where a specific person is involved, you might have to tread a bit softly in the aging area. Truth is one thing . . . outright cruelty another. However, if it's someone you don't really care for . . . Never mind; let's move on to the next chapter.

 HADING

When we think of shadow we think of light; shadow cannot exist without
light. When light plays upon the human face it darts over, in, and among
the planes of the face in constantly changing and interesting ways. In order
to shade the face properly, whether dramatically or not, it's necessary to
acquaint yourself with these flat, round, angular, hollowed, sharp, or pointed
areas, and that can be accomplished through highly focused observation
and a little braille. I really mean that. Feel your own face or your loved
one's; use the sensitivity of your fingers to investigate the nooks and cran-
nies and ruts and pouches that make up these faces of ours. Become so
familiar with your face that you could draw a face and imagine water drip-
ping from above and know exactly which areas would be wet and which
would be dry. Or picture a face with paint sprayed at it from one side, then
determine which sections of the face would be discolored and which would
be normal. After assimilating the planes and structure of the face, you'll
find that you will be able to use imagined light sources, without benefit of
a model or photographs, and find the correct shadows for yourself.

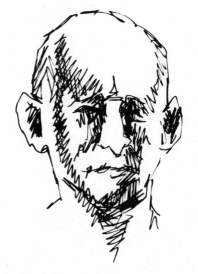

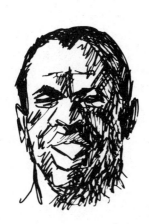

I believe in working very loosely at the beginning (much as in the exercises we discussed in the earlier chapter on portraiture). Look at your subject and then, without any planning or sketching, begin to scribble or mark in only the shaded areas. Try to capture the essence of that face or that fleeting expression with only the use of shadows; don't outline or deal with the usual contours of the face.

I also recommend using extremely high-key lighting and marking in clean, sharp shadows. This helps to develop your eye so that you can find that angle in the nose, or that wrinkle about the eye, just by using solid blacks.

Don't try, at this point, to even be aware of a resemblance; attempt, rather, to divorce yourself from the image as a face. Think of what you're seeing as just abstract shapes and shadows, and you'll be amazed at the end result. A wonderful piece of advice was given to me some years back regarding acting (especially acting at auditions, where nerves run extremely high); this wise person suggested to me to live, as an actor, only in the immediate present. That is, there is no future (will I get the job, will I be able to pay those outstanding bills, will I become a star?) and no past (the last time I auditioned for these people I didn't get the job, so they must hate me). The mind-set frees you up so that you're able to concentrate entirely on the work at hand, and it's what I'm suggesting, in essence, here. Don't think about the end result—that you couldn't do it on your last try, or whether you'll ever be able to do it—merely focus on the shadows and reproduce them. Accomplish that and the rest of it will fall into place as if of its own accord.

I did the following group of drawings in that manner, without any sketching (of course, you're going to have to take my word for it). I merely looked at the pictures and went for the dark areas, thinking of them as abstract shapes having no relationship to a human face. It's a valuable exercise, and one that I urge you to try and try again. Only, of course, if you don't succeed the first time.

This illustration gives you an extremely simplified view of the planes of the face. I'd recommend your getting familiar with them.

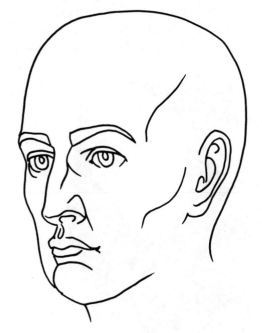

You can see how the flat, broad area of the brow cuts in deep over the eyes but tapers off gradually on the sides as it flows into the line of the cheek. Light would do the same thing; it would travel smoothly over the brow but then make an abrupt change to black as it encounters the eye sockets. The nose has sharper angles to deal with, and the hollows and bulges around the eyes reflect the light and produce shadows in very interesting ways.

In profile these planes are less pronounced, since we're exposed to the broadest and flattest of the facial areas.

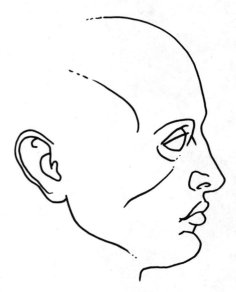

Even in a cartoon the planes of the face are utilized, as in this rendering of a satanic-looking chap.

Light from above produces a dramatic, sometimes eerie effect, arresting but not terribly flattering.

Side lighting is the most common technique you'll encounter. You can see how the light spills over the opposite cheek and then fades away into the hair and cheek.

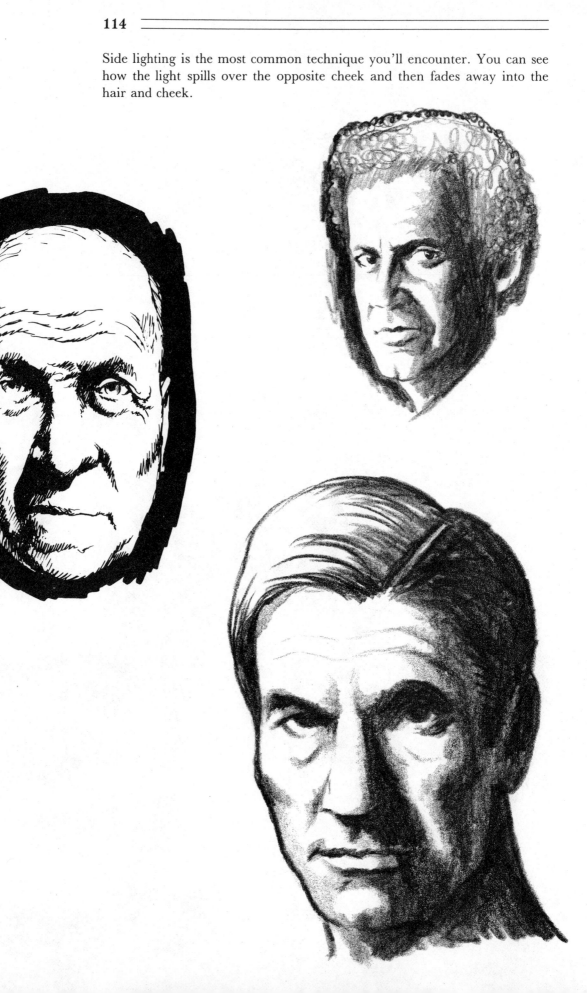

Lighting from below produces an eerie, sinister effect and is rarely used except in class-B horror films. But it's a good exercise just to see how light dances over the contours of the face.

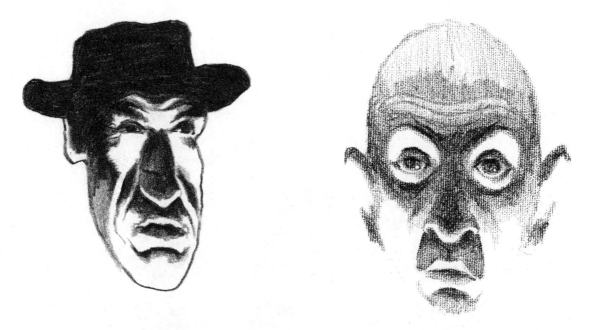

Lighting coming from both sides simultaneously produces a central shadowy ridge on the face, making for a highly dramatic effect.

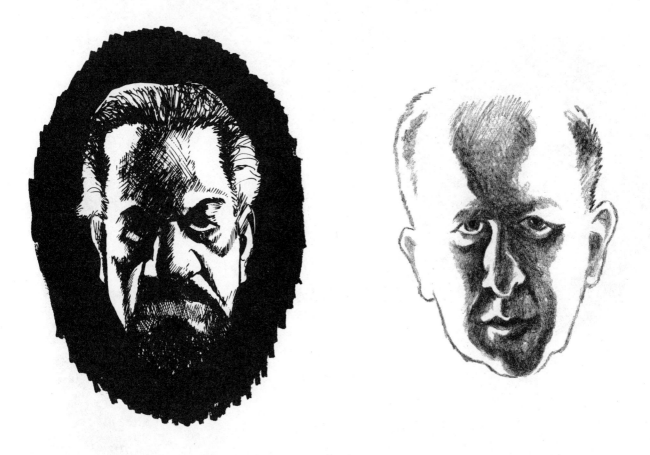

It's also interesting when half of the face falls into complete silhouette darkness.

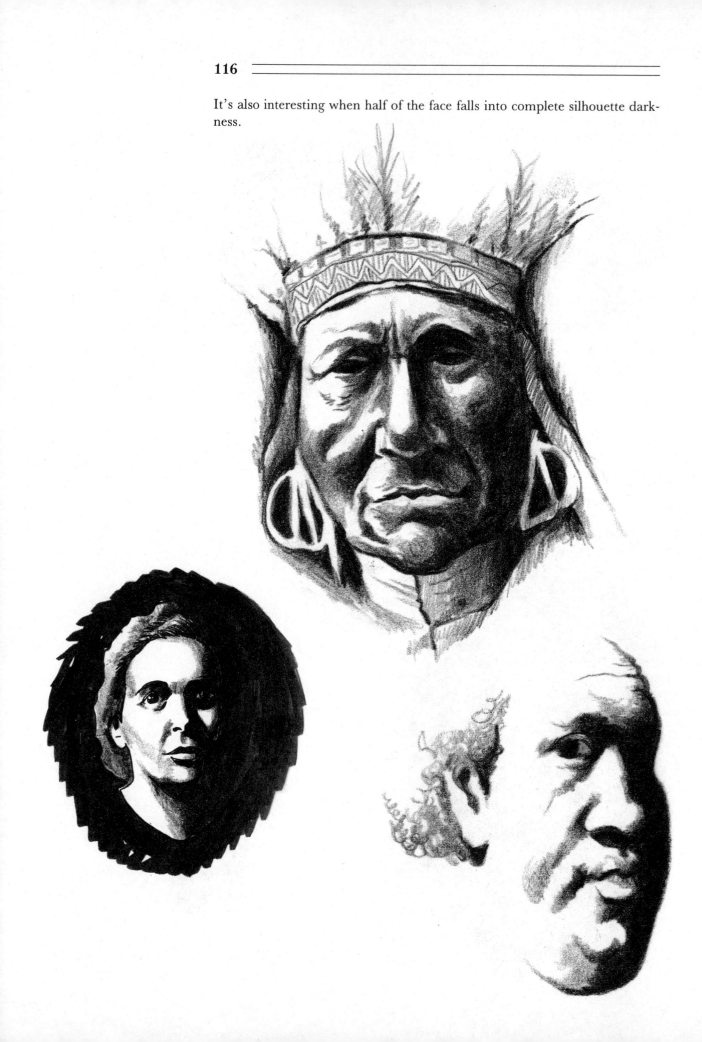

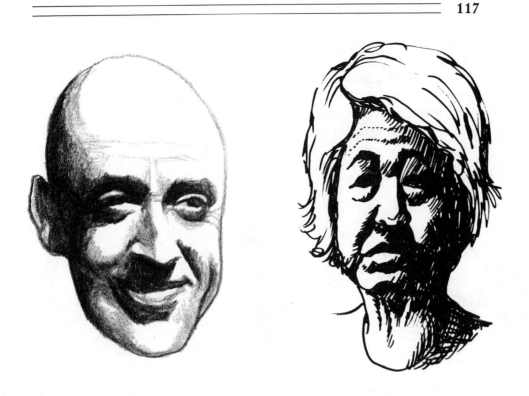

The goal in all of this is to achieve a three-dimensional illusion, to create a rounded-out feeling of the mere two dimensions on a piece of paper or a canvas.

Reflected light plays a large part in achieving a three-dimensional feel. If there wasn't such a thing as bounce light, most works would appear flat and consequently less interesting.

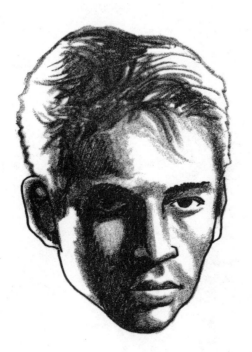

The lighting skills that you'll be dealing with primarily are the subtler shadings. Learn to develop a light, delicate touch with your pencil. Whereas before we dealt with the harsh, clean, sharply etched shadows, now we'll address the nuances of shading. And once again, don't sketch out the face in the conventional manner; just use your pencil softly and see what you can accomplish without those contoured lines.

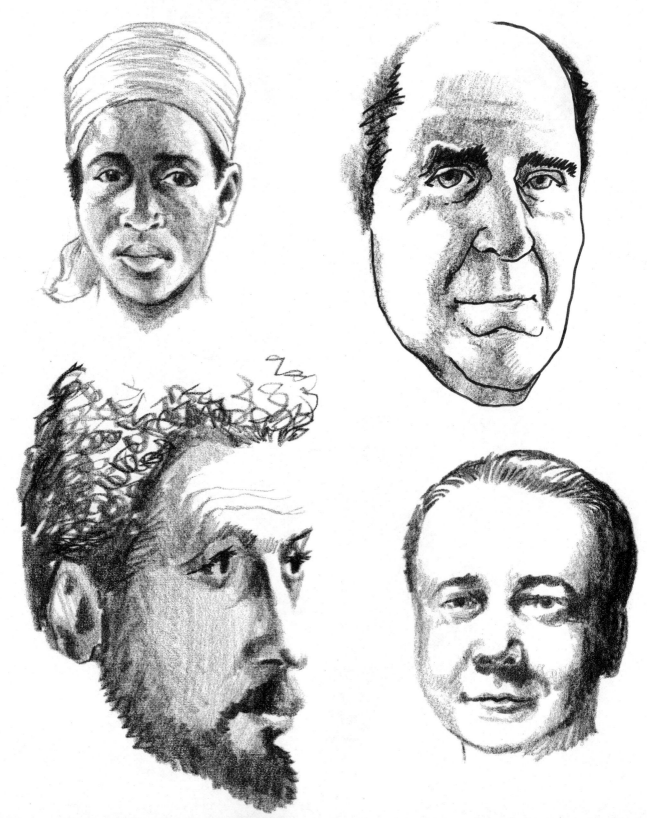

Light and shadow also play a vital role in caricature and cartoons. It's not just for formal portraiture.

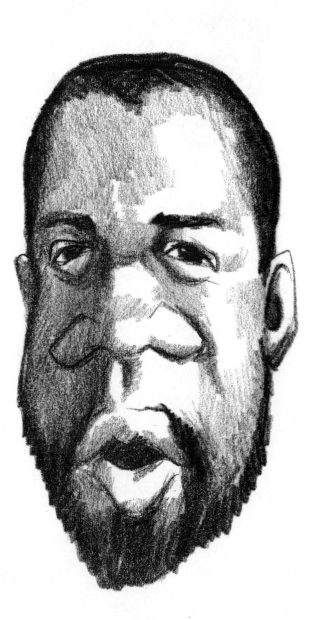

These humorous drawings have been aided enormously by the addition of shading.

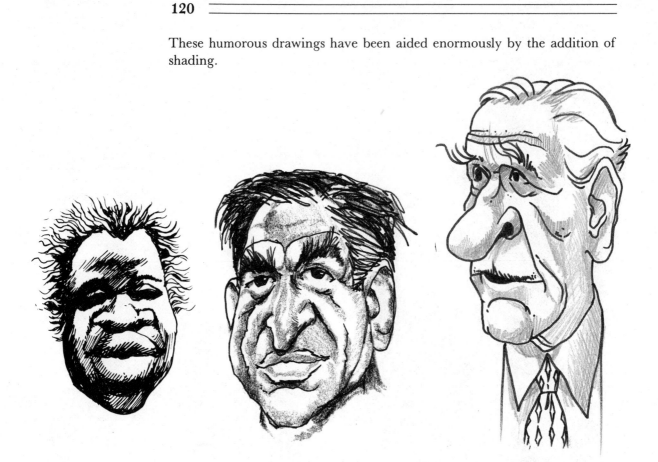

Here's a simple little cartoon face . . .

. . . but see how greatly improved it is merely by the addition of just a little shading? It gives dimension to the face, brings it out so it's not just a flat drawing.

Take this cartoon face . . .

. . . and give it some substance by using
a thick-thin line technique . . .

. . . and then one step further into more subtle variations
to round it out further.

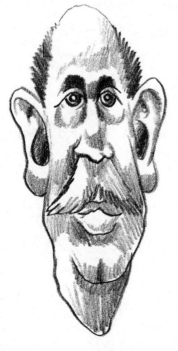

Here are some additional cartoon faces stressing the shading aspect. Try to picture them without the shadows and hot light sources that allow them to rise above the average cartoon drawing.

It's our job as artists to become aware of that constant interplay of shadow and light, and develop the observational skills necessary to re-create that magic moment when our eye perceives something worth capturing in a drawing or a painting. I have used limited materials in this chapter: ink, pencil, charcoal, and grease pencil. If you begin to experiment with other media, as I heartily recommend you do, you'll find so many more ways to capture that feeling, to express that distinctive curve, that soft delicate transition from brow to cheek. You'll find this an extremely rewarding aspect of this process of learning to draw the human face; it enriches and lends substance to your work.

CLOSING

When I decided to tackle a book strictly about the face, I had some quiet misgivings, wondering if there really was enough material to fill a book of this type. Well, obviously I had nothing to worry about. We've barely scratched the surface. I think we've all learned that the human face is a constantly changing, endless source of fascination, and if we as artists can develop the ability to freeze it in time for a few golden moments in a drawing or painting, we can be rightfully proud of that accomplishment.

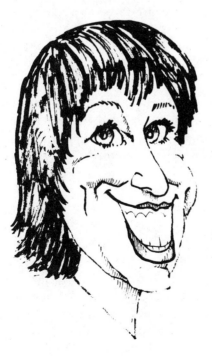

What else can I say after I've proselytized, urged, wheedled, pontificated, chastised, lectured, browbeaten, harassed, warned, and threatened you? All I know is that to become an artist in any area of endeavor, you must never let your imagination or your enthusiasm wane. Find a way to keep that fire of ambition burning, and don't allow those feelings of doubt to close in on you. If you do, they will form a wedge between you and artistic excellence. However, if you seriously aspire to be an artist and you are firm in your resolve, nothing can stand in your way. The good old three P's can guide you through the darkest and most discouraging of times: practice, passion, and perseverance.

What the process comes down to is this: you gotta use it. Use whatever you may have learned from this book (and I sincerely hope it's a great deal), use the sea of faces around you, use what you learn anywhere and everywhere. The library is a rich source of reference material, both visual and textual—and the price is right.

So now that you know what is required of you, get busy. Grab a handful of charcoal sticks and start creating some swift, loose portraits, or take pen in hand and toss off a series of silly cartoon faces, or take your pencil and pad to the park and caricature an unsuspecting couple seated across the way. Take your sketchbook with you whenever and wherever you possibly can. Draw. Sketch. Cartoon. Caricature. Endlessly and joyfully. Fill the pages with drawing after drawing after drawing. It's the only real solution for artistic frustration, and, incidentally, the only way to learn. I said at the beginning that I couldn't teach you, I could only guide you. You'll teach yourself; that is the truth. There are no shortcuts, no easy ways to refine

this skill. But it's the most pleasant apprenticeship you'll ever serve, and ultimately one of the most rewarding. Good luck to you in your career. I hope that I have, in some small way, steered you in a positive direction, or at least spurred you on to aspiring to greater things and the pursuit of artistic dreams. The wonderful thing about dreams is that they are within our grasp; we merely have to reach out for them and bring them to life.

About the Author

Dick Gautier was drawing cartoons for his high school paper in Los Angeles when he was sixteen, singing with a band when he was seventeen, and doing stand-up comedy when he was eighteen. After a stint in the Navy, he plied his comedy wares at the prestigious "hungry i" in San Francisco for a year before traveling to the East Coast, where he performed in all the major supper clubs; among his appearances was an extended run with Barbra Streisand at the Bonsoir in Greenwich Village. He was tagged at the Blue Angel by Gower Champion to play the title role in the smash Broadway musical *Bye Bye Birdie*, for which he won Tony and Most Promising Actor nominations.

After two years he returned to Hollywood, and eventually starred in five TV series, including *Get Smart*, in which he created the memorable role of Hymie, the white-collar robot. In addition, he portrayed a dashing but daffy Robin Hood for Mel Brooks in *When Things Were Rotten*.

Add to this list guest-starring roles in more than 300 TV shows, such as *Matlock, Columbo,* and *Murder, She Wrote*, and appearances on *The Tonight Show,* and roles in a slew of feature films with Jane Fonda, Dick Van Dyke, George Segal, Debbie Reynolds, Ann Jillian, James Stewart, etc., etc. He has won awards for his direction of stage productions of *Mass Appeal* and *Cactus Flower* (with Nanette Fabray), and has written and produced motion pictures.

Gautier is the author/illustrator of *The Art of Caricature, The Creative Cartoonist,* and *The Career Cartoonist* for Perigee Books, and a coffee-table book with partner Jim McMullan titled *Actors as Artists*. He's done just about everything but animal orthodontics, and don't count him out on that yet. No wonder he refers to himself as a "Renaissance dilettante."

Of all his accomplishments, Gautier is proudest of the fact that he's never hosted a talk show, or gone public with tales of drug rehabilitation and a dysfunctional family life.